POSTCARD HISTORY SERIES

Galena

Copyright © 2007 by Kay Price and Marian Hendrick
ISBN 978-0-7385-5114-2

Published by Arcadia Publishing
Charleston, South Carolina

Printed in the United States of America

Library of Congress Catalog Card Number: 2006939556

For all general information, contact Arcadia Publishing at:
Telephone 843-853-2070
Fax 843-853-0044
E-mail sales@arcadiapublishing.com
For customer service and orders:
Toll-Free 1-888-313-2665

Visit us on the Internet at www.arcadiapublishing.com

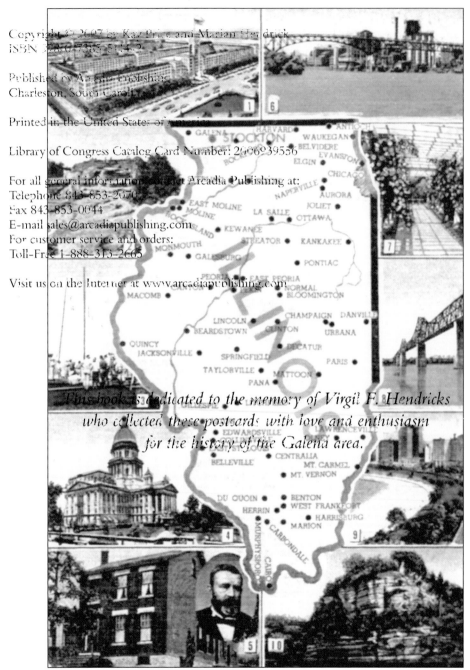

This book is dedicated to the memory of Virgil F. Hendricks who collected these postcards with love and enthusiasm for the history of the Galena area.

Galena is located in the upper northwestern tip of Illinois. (Courtesy of the Greene Collection.)

On the front cover: A statue of Ulysses S. Grant in Grant Park overlooks Galena. (Courtesy of the Virgil F. Hendricks Collection.)

On the back cover: A "launch parade" of festive passengers aboard cruise boats leisurely enjoy an afternoon on the Galena River. (Courtesy of Carl Johnson.)

POSTCARD HISTORY SERIES

Galena

Kay Price and Marian Hendricks

ARCADIA
PUBLISHING

CONTENTS

ACKNOWLEDGMENTS

We would like to thank Kaye Coyle from Dubuque, Iowa, for allowing us to use the photographs of her late husband Bob. Bob Coyle's artist eye captured much of the beauty and history of Galena. His photographs were put on postcards for decades, and many found their way into Virgil Hendricks's collection. Kaye and her son, Robert, were most gracious about lending their support to this book.

We want to thank Carl Johnson and his wife, Marilyn, for their assistance. Carl gave us his blessing to use a couple of his watercolor postcards. His art hangs in both of our homes so we already knew how important his artistic contribution was to our book. He and his wife offered to let us use a card from their own Old Stockade Collection that is found on the back cover of this book. Carl's art can be found at the Carl Johnson Gallery at 202 South Main Street in Galena. His Web site is www.cjart.net.

Our appreciation is also sent to Nancy Lewis for her permission to use cards in this book that were originally produced by her father Eldon Glick's company, Glick Enterprises. Many of the older views that we wanted to show had been taken by photographers working for her family business. She helped us when we needed it.

We send our highest praise and thanks to LaVerne and Donna Greene for their generous natures. When we realized we were short of certain cards necessary to tell the story of Galena, LaVerne did not hesitate to offer his very fine collection. We could take whatever we wanted. When we had questions and needed to verify historic facts, either LaVerne or Donna knew the answers. We are both extremely grateful.

We tried to give credit to the artist whenever we could. Sometimes postcards are not marked or are in a foldout that does not indicate who took the picture. If we missed acknowledging anyone, we apologize for our oversight.

INTRODUCTION

Words spoken are free as the air / Words written are always there.

—Marian Hendricks

This book is the direct result of Virgil F. Hendricks's love of Galena and Galena-themed postcards. I met him and his wife Marian on the old high school elevator. I was moving into the top floor apartment, and they were setting off to find a new postcard at an estate sale. We became fast friends. Virgil invited me over to see his postcard collection. I was already falling in love with Galena's rich history, but Virgil's enthusiasm added to my own desire to learn more. I realized that Virgil could teach the history of Galena through his postcards.

Years later after Virgil was gone, his wife Marian and I continued to enjoy our friendship. One day I asked her what happened to Virgil's postcards, and Marian went to fetch a big shoebox. Looking through the cards and reading the messages, I realized what treasures Virgil had left behind. Marian and I decided we wanted to share his collection with other Galena enthusiasts. This was the birth of this book. Marian told me that Virgil was inspired to search tirelessly and relentlessly for postcards depicting scenes of his beloved Galena. For this we want to thank him, because his hobby will bring joy to whoever reads this book.

It is difficult to spend much time in Galena without getting caught up in a love affair with its history. Postcards have a special way of telling you stories long forgotten of another place in time. They teach you to appreciate how things came to be because of the people who preceded you. Brief scribbles and short notes are often all that is left of people long forgotten and dead. Yet when you see their handwriting and you read their words, a bit of their lives live on in their message. Their only voice is written on a postcard. You wish you could have known them. You want to tell them how things are in Galena today.

Something deeper disturbs you, and you suspect there is another layer of genetic connection to this land. Imagine my surprise when I learned that my distant ancestor had originally owned the land on which sits the old high school, the building that I was determined to live in. None can explain the dimension of the past that calls out to us to join it. All we know how to do is to follow the path. This is our time to leave imprints on those long Galena steps. And yet with each footstep we stand in the space where countless others once stood. We see them in the postcards.

When you look at a postcard that shows a place of beauty, you want to go there and see it as the artist saw it. You long to go back to that place and that time, for just a moment, to see it as

it was then. You realize that we are trapped in our own place in time, and we must make do with examining old postcards for clues to what we are missing.

Think how much fun it would it be to ride a steamboat up the Galena River and to come around that final bend for your first glimpse of this picturesque river town. Imagine being there when someone struck it rich in the mines and became wealthy overnight. Pretend for a moment that you are hiding out in the Old Stockade in fear that Chief Black Hawk will take your scalp before morning light. Better yet, how about watching Gen. Ulysses S. Grant pull into the old depot for a hero's welcome after the Civil War? Now that would have been the party of all parties to attend. The best miners' pasties in town would be served.

To have tea with Julia Dent Grant would have been an honor; there are many questions to ask her about her husband. At least in the postcards you can spy inside her home and see her china, her bedroom, and even her chamber pot. You can wander through all the mansions of Galena, if you have the right postcard. You can live through the horrible floods without getting your feet wet, climb those steep steps without getting winded, ride down the Old Stagecoach Trail without getting dusty, and spend the night in the comforts of the Desoto House Hotel. Who knows, maybe Ralph Waldo Emerson will be in the next room.

Perhaps instead of showing us our limitations in transporting time, the charm of postcards is that it offers freedom to travel without the restrictions of our daily life. They enable our minds to run wild and convey us back to any place or time. We can freely mingle with all the characters of Galena's past. The only passport we need is a postcard to open up the door. Here in this book are some of the finest postcards in town. They will give you a history lesson unlike any other. There is no telling who you will meet along the way.

—Kay Price

This postcard captures the quintessence of Galena. (Courtesy of the Greene Collection.)

One

EARLY SETTLERS
MINED DREAMS

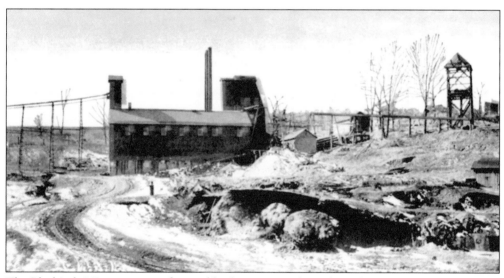

The Blackjack Mine was one of several lead ore mines along the Galena River. Early explorers discovered the lead ore mines near the Fever (Galena) River in the late 1600s, and word spread of their existence. The Native Americans began to realize their potential value, but they were ill equipped to mine. They only scratched the surface and did not go underground. In 1822, Col. James Johnson of Kentucky came with 100 men for the sole purpose of mining. This group included about 50 black slaves. As the mining industry took hold, the miners' dreams to get rich quick were repeated by thousands of hopeful men who flocked to Galena. Many miners were poverty-stricken and unable to feed their families. They borrowed from the local merchants. Some were lucky, like Hezekiah H. Gear. One day he rode through town on his horse gathering up his debtors. He took them to the spot where he struck the lode that made him instantly one of the richest men in Galena. Many lucky fortune hunters found riches mining these hills.

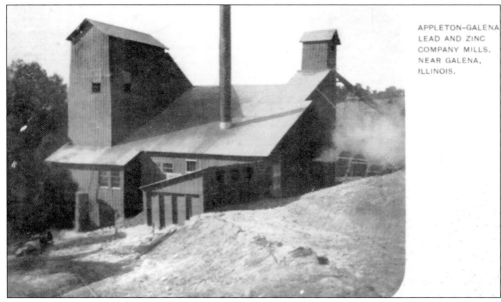

APPLETON-GALENA
LEAD AND ZINC
COMPANY MILLS,
NEAR GALENA,
ILLINOIS.

The Appleton-Galena Lead and Zinc Company Mills were near Galena. It was one of several mines in the Galena area.

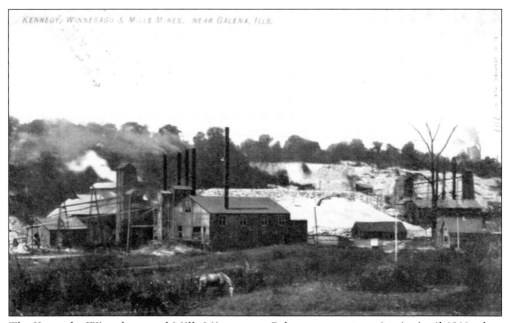

KENNEDY, WINNEBAGO & MILLS MINES, NEAR GALENA, ILLS.

The Kennedy, Winnebago and Mills Mines, near Galena, were prospering in April 1910 when this card was sent. The numerous smoke stacks imply that a great deal of smelting was ongoing. The ore was smelted in a furnace and poured into molds to solidify and become "pigs" of lead. This allowed for easier handling and shipping. This card says, "Dear Lizzie . . . I will drop you a line this evening telling you I am well and hope this finds you the same." Concerns about health were uppermost in people's minds, as they worried about smallpox and malaria, and the miners suffered with black lung disease.

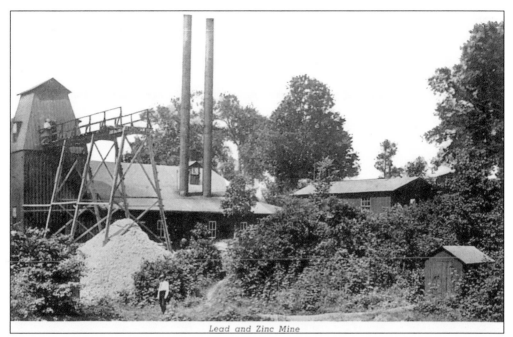

Lead and Zinc Mine

This lead and zinc mine near Galena was heavily worked by the miners. Lead was melted down and made into gunshot. It was used to make ceramic glazes and alloys, plumbing, and solder. Zinc was used to make early kitchen sinks, as well as other things now made out of aluminum. Mountains of tailings and lime rock were left behind; there was enough to make all the roads in the state of Illinois. Piles of tailings can still be seen on some rural roads around Galena.

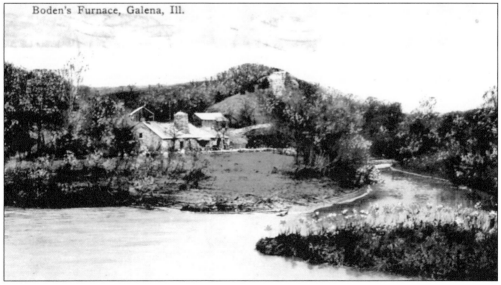

Boden's Furnace, Galena, Ill.

Boden's Blast Furnace near Galena provided a more sophisticated method of mining that operated 24 hours a day. It was constructed to cause the heat from the fire to pass over the mineral. It required more labor but less need for the local trees used for the ash and log furnaces. The smelting processes improved greatly in the late 1840s. There was a larger profit from this kind of smelting operation, even though the government had begun to demand a leasing fee that forced the miners and smelters to follow leasing regulations.

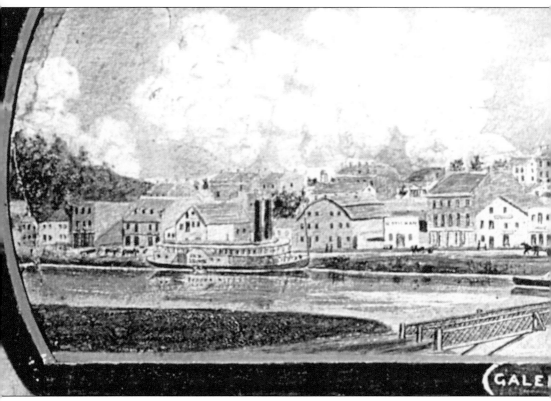

This is the oldest picture of the Galena Levee, painted by Maj. A. S. Bender in 1844. Major Bender was an engineer in the office of the United States Superintendent of Mining Lands at Galena from 1843–1847. In 1885, he was employed as an engineer by the Hawaiian government and was

EE. 1844.

engaged in putting in a water supply and a sewage system in the city of Honolulu. The loads of lead ore were hauled here and put on steamers and barges to take down the Mississippi River. This image became symbolic of "The River of Mines" term used to describe the Galena area.

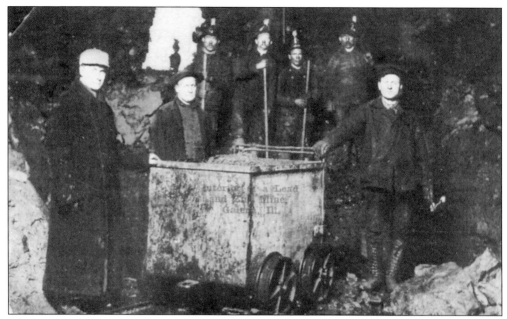

The interior of a lead and zinc mine shows the miners with a wagon full of lead ore. It was a difficult way to make a living, but the dream of riches kept the miners warm in the damp, cramped, old tunnels of the mines. Their typical lunch was a pasty made from meat, potatoes, and onions baked in a pastry turnover crust. It stayed warm all day in their lunch pail. When the mining industry vanished, the mining culture continued to influence the surrounding area. (Courtesy of the Greene Collection.)

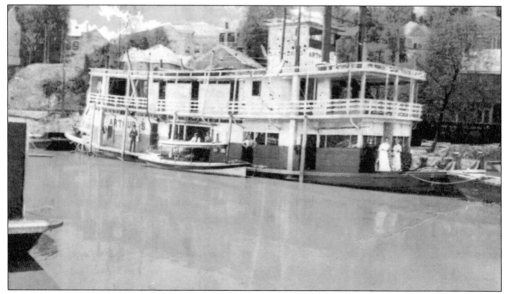

The *Arthur S.* at the Galena Levee is one of as many as 10 steamboats that came to Galena each day. They usually included two keelboats to help navigate the rapids of the Mississippi River. As the steamboat industry grew, most of the boats were engaged in transporting the lead ore. Many Galena residents became captains and owners of the steamboats.

Two

GLORIOUS GALENA RIVER

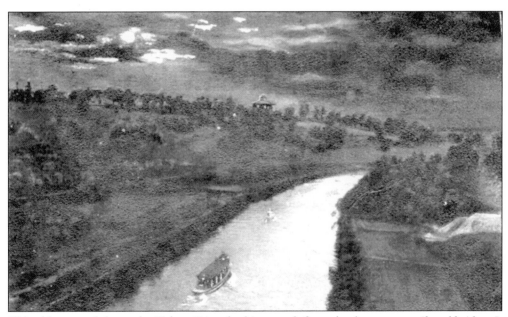

This old postcard shows the Galena River looking south from the downtown railroad bridge. It is a dark and stormy night to the right of the picture, but a full moon is shown on the left. The important part of this image is that it shows the great width of the river, as it used to be before it was filled in with silt. Two big boats are about to pass each other. As the logging business stripped the hills of their trees, the dirt from the hillsides filled in the river with silt. The steamboats could no longer navigate through the narrowed channel. At the top of the hill, there is a big mansion with lights on. This was the Marine Hospital, built for the wounded and dying of the Civil War. The soldiers were brought up the Mississippi River to this hospital. The bank was steep and difficult to climb, and they had to be carried up. It closed after the war. People still spoke about the hospital with downcast eyes and heavy hearts 100 years later.

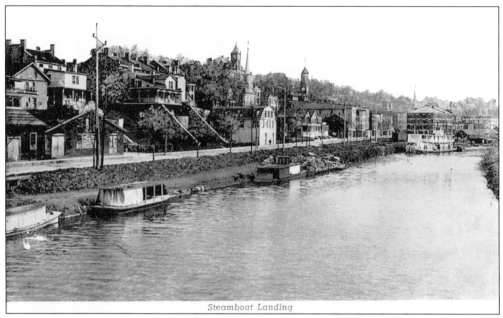

Steamboat Landing

Steamboat Landing was along the Galena Levee. Galena counted on the steamboats to bring their supplies and building materials. It was the highway system of the day. Important river transactions took place here. During the winter, Galena was shut down and quiet. As soon as the first steamboat made it up the river in the spring, the whole community cheered. The rest of the year Galena was busy and thriving.

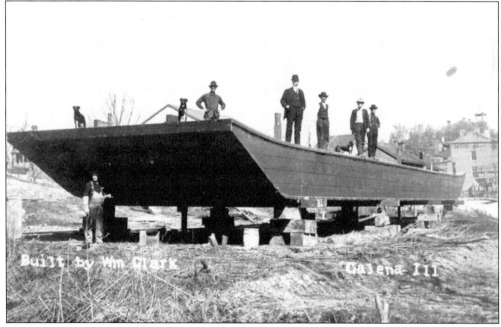

Men are helping William Clark build a barge next to the Galena Levee. (Courtesy of the Greene Collection.)

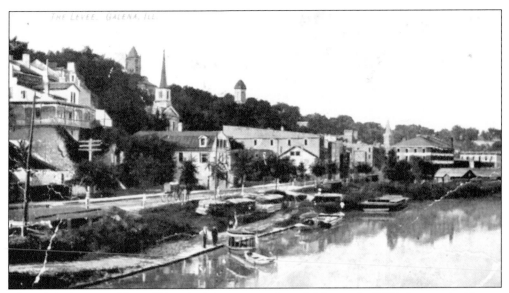

The original name of Fever River had the connotation of sickness. In 1853, the state legislature changed the Fever River's name to the Galena (a Latin word for lead sulfide) River. Life in Galena was at its peak. Commerce included banking, architecture, hotel, saloon, millinery, lumber dealer, gunsmith, saw mill, tailor, blacksmith, wagon maker, and medicine. Galena's trade made it the best business town that one could find before heading into the wildness of the west. Life was centered around the Galena River and this levee.

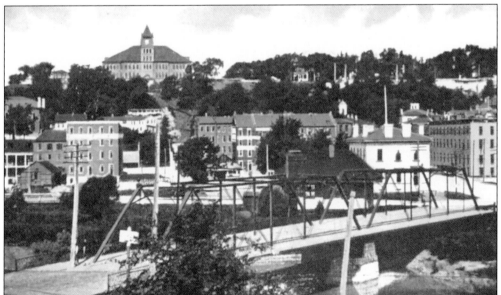

In 1819, a ferryboat at the bottom of Bouthillier Street crossed the Fever River. This card shows the new Green Street Bridge near where the ferry once operated. When this foot and automobile bridge opened, it connected the east and west side of town. It was nothing fancy, but it was functional and a much better version than previous bridges. It allowed people to easily walk across the Galena River from the residential side of town to the downtown business area. It also provided a spectacular view that proved Galena was one of the most beautiful and picturesque small towns in America.

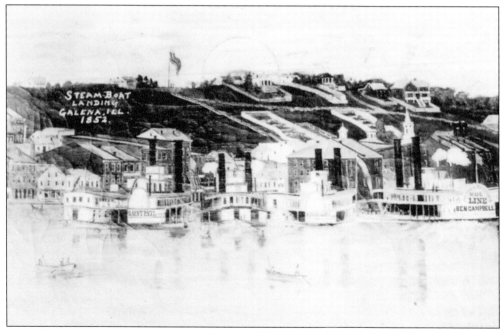

Birds-eye View looking South, and Galena River, Galena, Ill.

This 1919 view looking south down the river from Shot Tower Hill shows a bustling town with a railroad bridge, traffic bridge, and a footbridge. Although no longer an important river port, Galena's commerce remained active for the local and rural residents. The scenic beauty with its rolling hills and river bottoms continued to draw interested people to see the scenic area.

This 1852 view of Steamboat Landing shows three big steamboats at the Galena Levee: the *Saint Paul*, the *Minnesota*, and the *Ben Campbell Mail Line*. (Courtesy of the Greene Collection.)

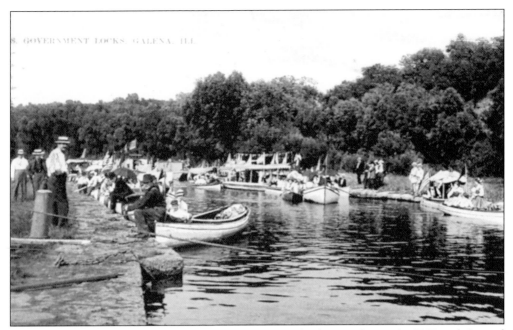

The United States Government Locks and Dam were built out of stone in 1890 and situated on the Galena River about three and a half miles from the city, where the river flows into the Mississippi River. The river channel continued to decrease in size; the combination of no river current and soil erosion caused the siltation to increase. The shallow river was too obstructed to allow steamboat traffic to continue to Galena. The locks and dam improved navigation for about six miles between the Galena and Mississippi Rivers. Boats could easily ply between the two rivers. The locks created a sportsman's paradise for boating, camping, fishing, and hunting. They operated until 1921, when river traffic again declined. This postcard is dated 1910.

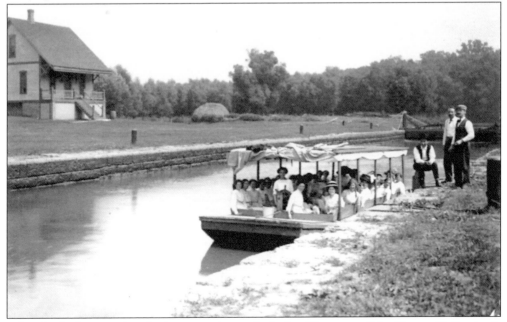

A boatload of women is enjoying an outing at the locks. (Courtesy of the Greene Collection.)

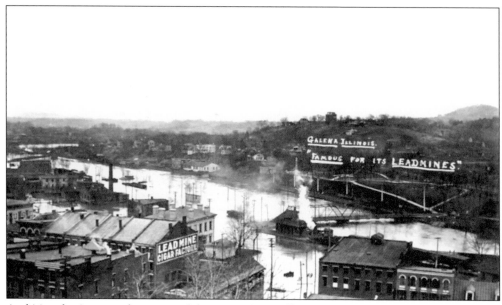

Ambitious businesspeople supported the miners in an effort to create this bustling riverboat town, which had a population of 14,000 in the mid-1800s. (Courtesy of the Greene Collection.)

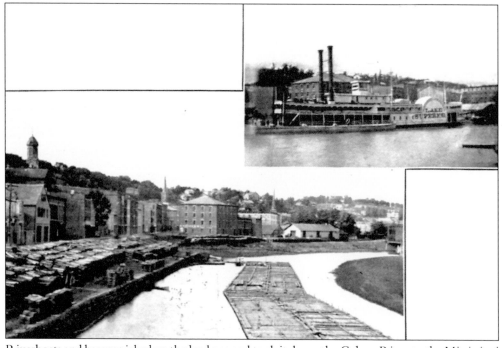

Riverboats and barges picked up the lead ore and took it down the Galena River to the Mississippi River and beyond. In 1840, the Galena River was 340 feet wide and deeper than the Mississippi River. In 1837, Galena had 127 steamboat arrivals. (Courtesy of the Greene Collection.)

Three

Many Churches

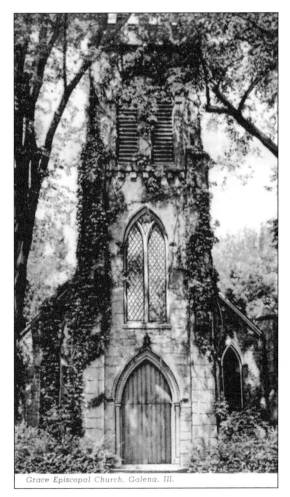

The Gothic Revival Grace Episcopal Church is located at the corner of Hill and Prospect Streets, high on a hill overlooking Galena. The steeple was removed after 1903. The 1838 Erban Organ was brought from New York City, by way of New Orleans, and from there up the Mississippi River. It is still in use. The church has a beautiful walnut altar carved by Guster of New York City and a lectern carved by Gronner of Galena. The windows are of imported Belgian stained glass. The front door is painted an inviting red. The church is literally carved from the rocky cliff behind, making it almost impossible to add on any additional space.

Grace Episcopal Church, Galena, Ill.

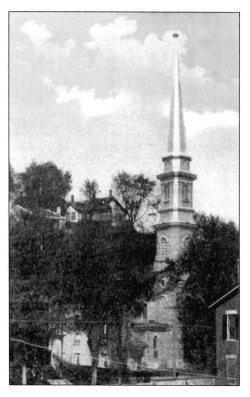

The First Presbyterian Church was erected in 1839 at 106 North Bench Street in the Romanesque Revival style. This is the oldest church building of any Protestant denomination in continuous service in the Old Northwest Territory. Pastor Aratus Kent, a Yale graduate, asked to be sent to "a place so tough no one else will take it." They sent him to Galena. It took him a month to get there from New York City, traveling by horseback and steamboat. This was the first church to bring the Gospel to what was then the country's western frontier. It started out with only six members. The building was built of native limestone, hand quarried from Galena's own hills. The steeple design (spire in Georgian) is a copy of the steeple at the Old North Meeting House in Boston. Yale University donated the pulpit and the four chairs that are currently in the front of the sanctuary.

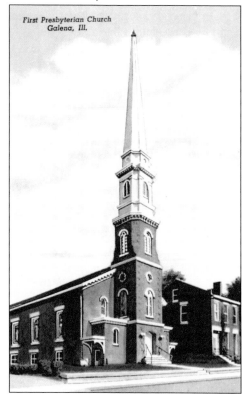

First Presbyterian Church
Galena, Ill.

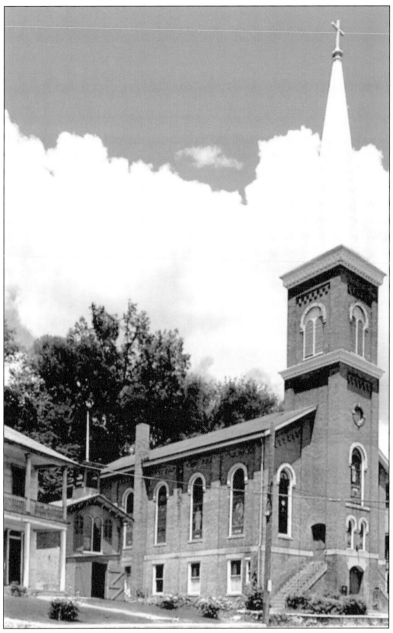

The First Methodist Church was built in 1856 at 125 Bench Street in the Romanesque Revival style. It is the oldest Methodist church in northern Illinois. In 1829, the first regularly appointed Methodist minister arrived in Galena. By 1832, a plain frame church was erected on Bench Street, but it was lost to fire in 1838. A new building was built in 1841, and by 1856 the congregation had grown so that yet another new brick and stone church needed to be built. The present church was dedicated in 1857. Ulysses S. Grant worshiped here regularly from 1859 to 1861. When he died, the church was draped in mourning and a memorial service was prepared. A Chicago paper was quoted as saying that in front of the pulpit was placed "a stand of pure white flowers, with the initials, U.S.G. in purple flowers." The pew formerly occupied by Grant was covered with the United States flag, tastefully draped. Today the pew is marked with a flag and a plaque. (Photograph by Joe E. Clark.)

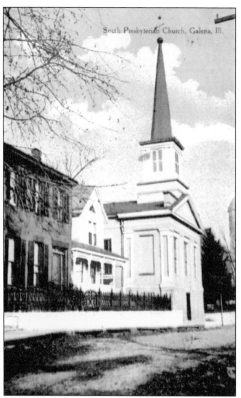

The Greek Revival South (now called the Westminster) Presbyterian Church is located at 513 South Bench Street. It was built in 1848. The small town of Galena would not normally need two Presbyterian churches, but this second church was built for those who supported the Confederates during the Civil War. The church was divided on their loyalties and the only way to solve it was to build a second church. The southern influence was strong, as can be seen around town with the much-used wrought iron railings brought from New Orleans up the Mississippi into Galena.

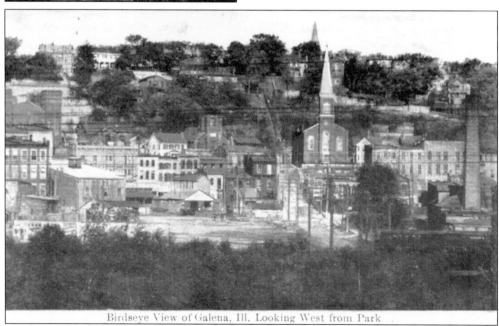

Birdseye View of Galena, Ill. Looking West from Park

Today five church spires greet the tourist who visits Galena. The churches are landmarks of the 1800s. After fires swept the town burning the wooden buildings, the villagers started to use brick to secure their structures. Brick became the most important building material in Galena. Fear of fire continues to be of utmost concern because the downtown buildings are closely connected.

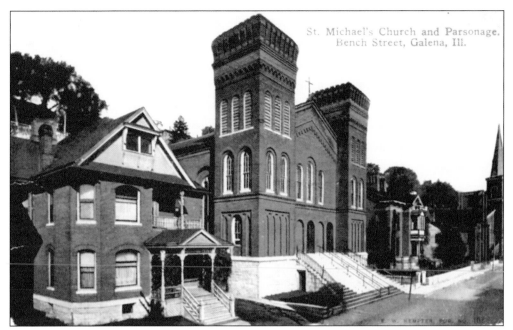

St. Michael's Church and Parsonage. Bench Street, Galena, Ill.

St. Michael's Catholic Church is at 225 South Bench Street and was done in the Romanesque Revival style. This parish traces its history back to 1832, when it was founded by the famous pioneer priest and architect Fr. Samuel Mazzuchelli. He served as pastor of the parish from 1835 to 1843 and, during this time, directed the building of a church. This Irish church served until it was destroyed by a fire that had consumed a good portion of downtown Galena. Father Mazzuchelli began working with St. Michael's parish to build a new building to replace the one lost in the fire. The new church still stands today and continues to serve as a place of worship.

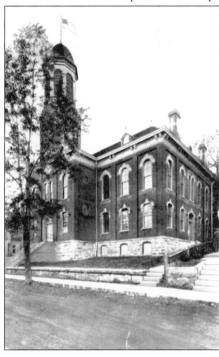

St. Michael's parish built a Catholic grade school to go with their church. It is a few doors down the street. Originally it was called the Annunciation School. It is now the Galena Art and Recreation Center. The second floor is a basketball court. It is used for a variety of community classes and functions. Father Mazzuchelli built over 20 churches in his career and started 40 parishes. He is currently being considered for sainthood by the Vatican in Rome.

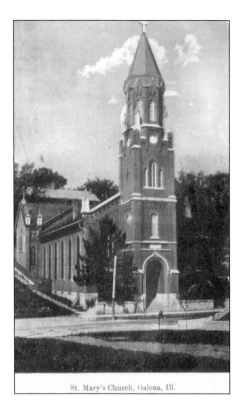

St. Mary's Church, Galena, Ill.

St. Mary's Catholic Church was started on 400 Franklin Street in 1856 by German immigrants. It was constructed according to the plans of missionary Fr. Samuel Mazzuchelli. The church was enlarged in 1865, and a steeple was added in 1876. Four years later, bells were added to the tower. In a small town like Galena, it was amazing to have two Catholic churches and two Presbyterian churches. The Irish and German locals insisted on having their own churches and own schools. They refused to enter each other's churches. Even today this continues to some degree, though one priest services both parishes.

St. Matthew's Evangelical Lutheran Church was erected during the Civil War in 1864. This Victorian Gothic building is located at 125 South High Street. It stands at the highest point in "Old Galena." At night, the lighted steeple can be seen for several miles. (Photograph by H. Brueckner.)

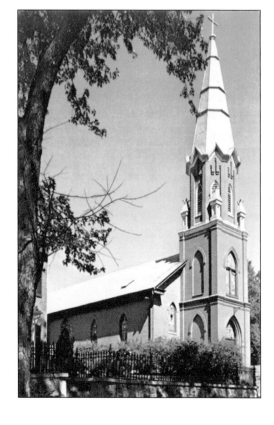

Four

ULYSSES S. GRANT'S HOMES

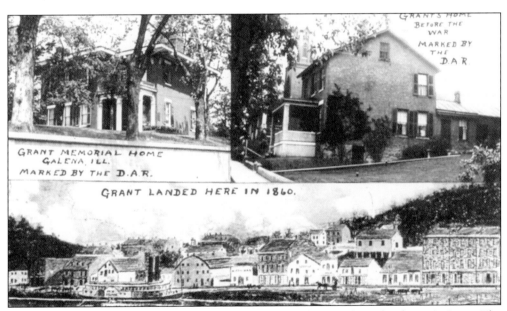

Greetings from historic Galena will naturally include anything to do with Ulysses S. Grant. The city is exceptionally proud of this Galenian citizen. Grant was a West Point graduate but was unable to succeed in business. He tried farming, real estate, and serving in the Mexican war. He had a wife and four children with no means to support them. Grant came up the river on the *Itasca* steamboat in 1860 traveling from St. Louis to Galena. His brother and father promised to give him a job in the family leather store on Main Street. When the boat struck the landing he was seen carrying two kitchen chairs, one in each hand, as he stepped ashore. The carrying of the chairs ashore signified that Grant had become a resident of Galena. The town would be forever changed by his presence. He would not just be their hero, he would become their legend.

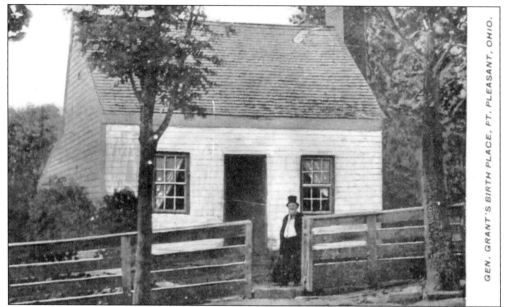

Unlike most of the presidents before him who were born in log cabins, Hiram Ulysses Grant was born in this small frame cottage along the banks of the Ohio River on April 27, 1822. The cottage was located in a valley of Point Pleasant in Ohio. Grant's father, Jesse, was a leather tanner, and his mother was named Hannah Simpson Grant. People who become fascinated with Grant end up wanting to know where he came from before he lived in Galena. These humble beginnings would hardly give a clue to the greatness of the man to come.

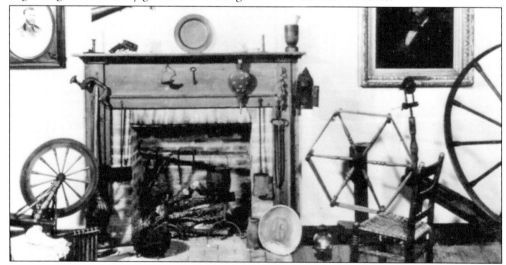

This is the kitchen in Ulysses S. Grant's birthplace. Here meals were prepared, and spinning, weaving, and other household tasks were performed. It was in this environment that Grant grew up under the watchful eye of his mother. Restoration of this interesting "center of activity" was effected under the supervision of the Ohio State Archaeological and Historical Society in Columbus. It was in this room that Grant's parents called him by his middle name, Ulysses, or Lyss for short. When he entered West Point in 1839, his name was mistakenly changed to U. Simpson. He then became known as U. S. Grant, rather than H. U. Grant, which stood for the initials for his given name, Hiram Ulysses.

This 1910 postcard shows the first house that Grant lived in when he arrived in Galena with his family. It was a very unpretentious two-story brick house on one of the steep hills that rose to a high elevation from Main and Bench Streets. To reach the house, Grant had to climb 175 steps. Visiting neighbors along the way shortened the climb and cemented the attachment that Grant had for his friends on the hill. He referred to it years later, after living in the White House, as the house he felt the most at home in, of all the houses he ever lived in.

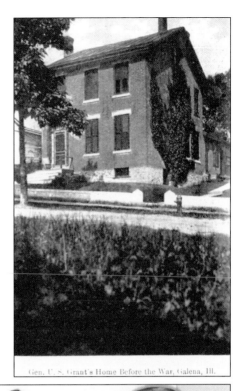

Gen. U. S. Grant's Home Before the War, Galena, Ill.

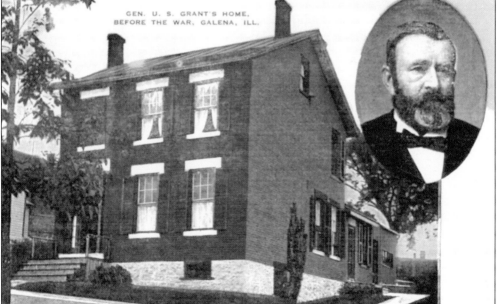

GEN. U. S. GRANT'S HOME,
BEFORE THE WAR, GALENA, ILL.

Curtains and shutters have been added to this shot of the house. A plaque outside tells tourists that Grant and his family once lived here, before he was called to lead the county in battle for the Civil War. While in this house, Pres. Abraham Lincoln called for volunteers to stop the uprising. Since Grant was a graduate from West Point, it was logical that he would train the men who planned to join up. His military skills were needed.

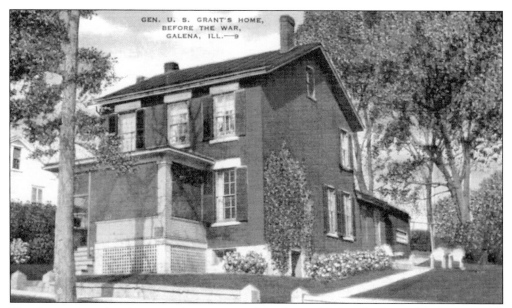

The shutters are painted green and a screen porch has been added to the front of the house in this view of Ulysses S. Grant's home. Julia Dent, Grant's wife, was known as a woman who adored her husband. She made him a cozy home. He was known to be so in love with his wife that he would button up her shoes for her every morning. In this house, he could enjoy being with his wife. He was weary of the military life that had separated him from his family. Yet it was from this house that he was once again called away to protect his country.

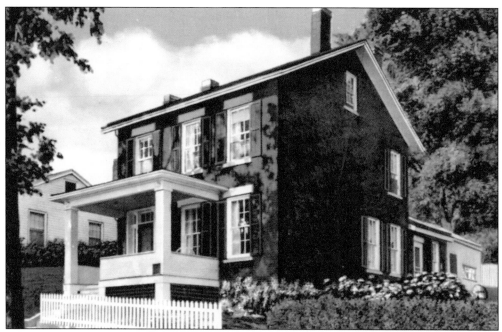

Another view shows that the screen porch has been replaced with an open porch. A white picket fence has been added. Both Julia Dent and Ulysses S. Grant loved living in this house on High Street. From this home, Captain Grant answered the call of his country in 1861.

This 1907 card shows the Green Street steps that Grant climbed to get to his High Street home more than 100 years ago. A trademark of Galena, these steep stairs often carried the aroma of Grant's cigar. A few blocks away, another set of steps offered an alternative path and some variety for going up and down the hillside. The stairs promoted physical fitness for all who daily made the climb. The steps have recently been replaced with new concrete and lights.

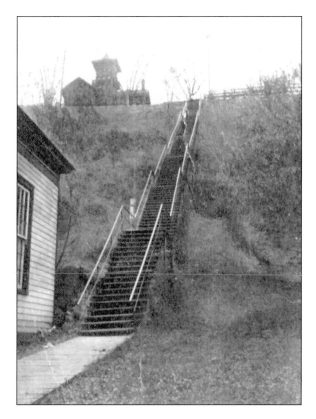

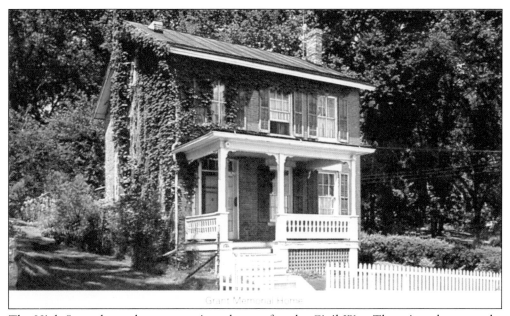

The High Street house became a private home after the Civil War. There is a plaque on the side of the door that says this is where Grant lived when he first came to Galena. (Photograph by Bob Coyle.)

When the Civil War finally ended, Ulysses S. Grant came back to Galena as a war hero. Private citizens of Galena raised money and gave him this house on Bouthillier Street as a sign of their appreciation for being the savior of the Union. They paid $2,500 for it. Galena has many famous landmarks in "the town that time forgot," but this is probably the best known. The house was presented to the Grants in 1865. Grant lived there quite comfortably for the next three years until he had to leave for Washington to become the next president of the United States.

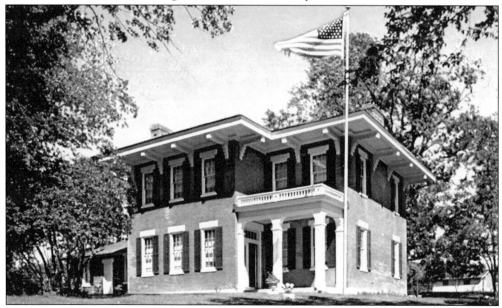

This was the Grants' post-war house in Galena. The flag is proudly flying. Visitors are welcome to see the original furnishings of the Grant family. This remains a very popular tourist destination today. (Photograph by Joe E. Clark.)

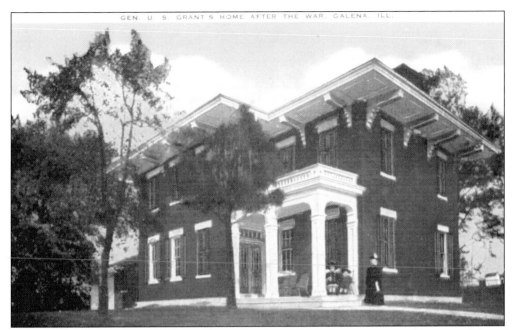

This image of a woman and two small children in front of Grant's house could very well be of Julia Dent Grant, the wife of Ulysses. She was the mistress of the house from 1865 to 1868. Her furnishings that were left behind tell a great deal about her tastes and what kind of woman she might have been. She followed her husband to the battlefield, camping with the muddy boot soldiers. She cared for the wounded. She knew that her husband needed her close in order to survive the immense pressure of his job. With the war now behind her, Julia could finally bask in the knowledge of her husband's secure place in history and in creating a new home for her family.

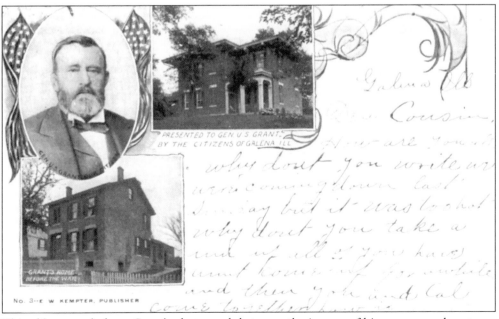

This old postcard places Grant's photograph between the images of his pre-war and post-war homes. (Courtesy of the Greene Collection.)

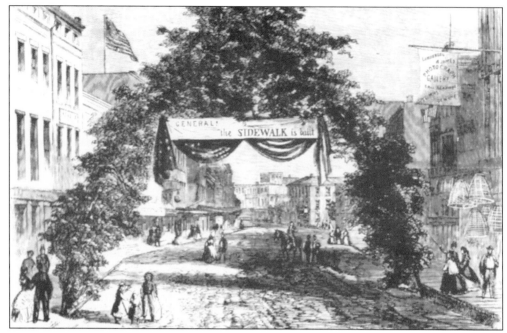

On August 18, 1865, the citizens of Galena greeted the return of its victorious general with a grand celebration. A "grand triumphal arch" spanned Main Street, and a holiday atmosphere prevailed with a jubilant procession, speeches, and evening fireworks. Julia Grant recalled that "there was a tremendous and enthusiastic outpouring of people to welcome him . . . After a glorious triumphal ride around the hills and valleys, so brilliant with smiles and flowers, we were conducted to a lovely villa exquisitely furnished with everything good taste could desire." (Courtesy of the Greene Collection.)

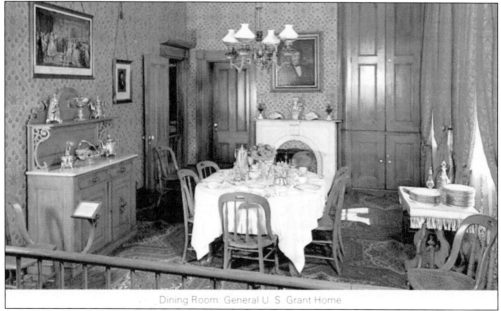

This postcard shows off Julia and Ulysses Grant's new dining room. (Photograph by Bob Coyle.)

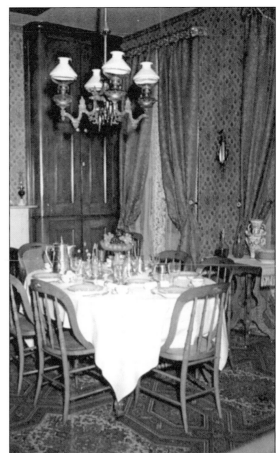

Grant's only daughter, Ellen, was married in a lavish ceremony at the White House in 1874. The menu, written in gold gilt on white silk and fastened with a ribbon in a bridal knot, was at each setting. The special-made Haviland china and flatware created for the wedding are displayed in this house. The china is inscribed with a gold G.

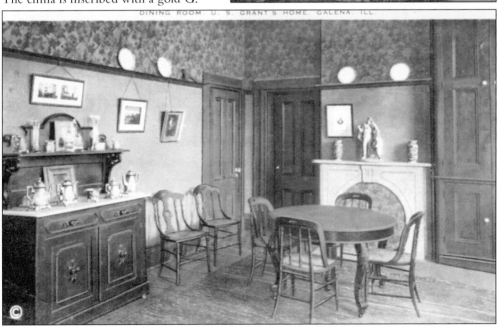

DINING ROOM, U. S. GRANT'S HOME, GALENA, ILL.

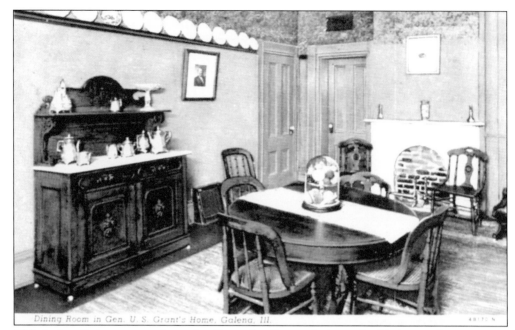

Dining Room in Gen. U. S. Grant's Home, Galena, Ill.

This is the dining room where the Grant family ate their meals. To know that someone so important to American history laughed and relaxed at this table is to understand how special they were to the history of Galena. The ambiance of their presence lingers in their personal belongings.

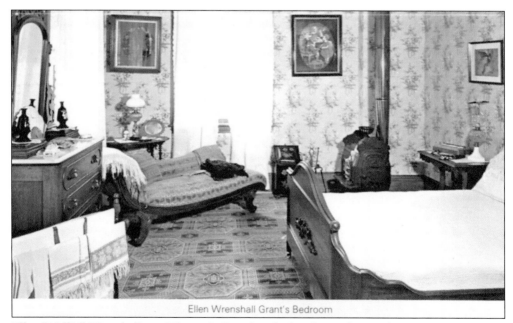

Ellen Wrenshall Grant's Bedroom

Ellen "Nellie" Wrenshall was Ulysses S. Grant's only daughter. This was her room in the house. She was spoiled by her father, and she lacked nothing a teenager could want. He disappeared on her wedding day and was found sobbing. (Photograph by Bob Coyle.)

This was Grant's bedroom. He slept in this room while he planned his campaign for president of the United States.

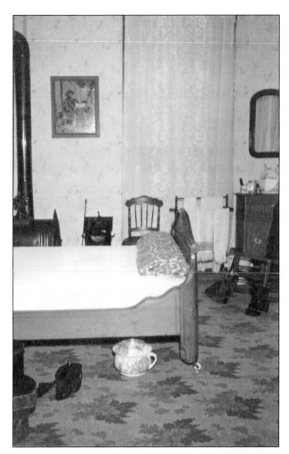

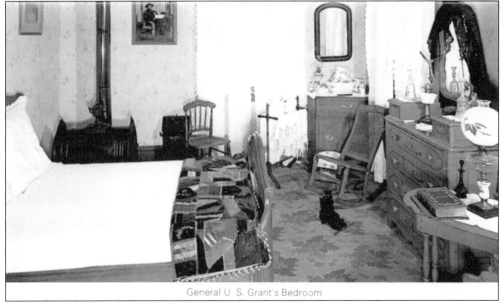

General U. S. Grant's Bedroom

Simple but elegant for its time, this bedroom must have been a welcomed luxury for Grant after living in the Civil War camps. (Photograph by Bob Coyle.)

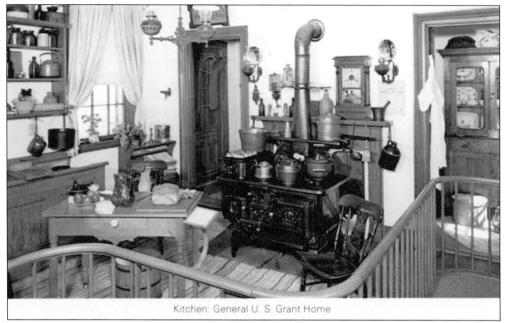

The kitchen in Ulysses S. Grant's house was well laid out for baking and cooking in the 1865 style. A pantry off the kitchen held the necessary supplies. The stove, table, and four chairs are original furniture used by the Grant family. (Photograph by Bob Coyle.)

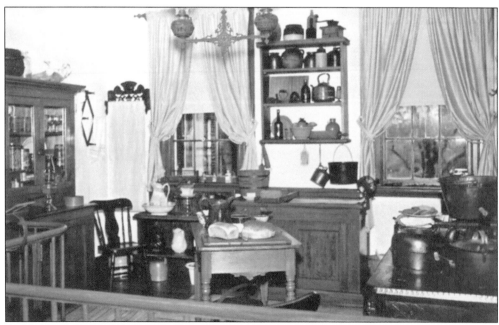

Grant refused to eat meat unless it was burned. He said it was the result of working in the family tannery and seeing so much bloody meat.

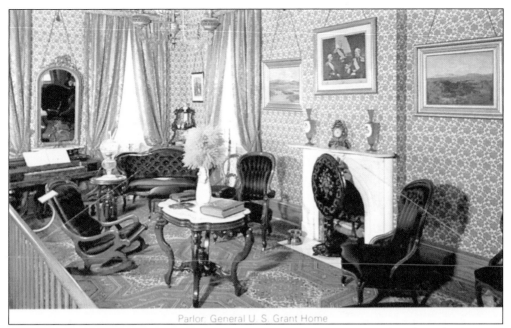

Parlor: General U. S. Grant Home

This lovely parlor has a fireplace and the Grant home piano. The woodwork in this house is original, but the windows, walls, and carpet have been restored to represent the time period of the Grants. The family liked some of the house furnishings so much that they took pieces of the furniture with them to Washington, D.C., when they left. (Photograph by Bob Coyle.)

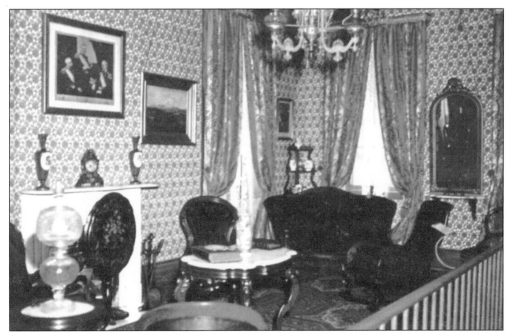

Many a lively reception was held in this room as Grant campaigned to become the U.S. president.

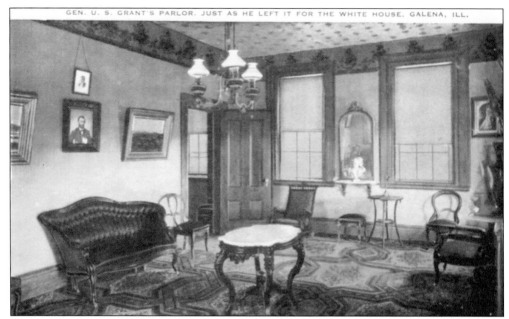

People of this time period were fond of sending postcards that showed the intimate details of the inside of Ulysses S. Grant's home. It allowed the average person to get a glimpse of what their hero's life was like after the war. There were many cards made showing each room of this house. This one points out that the parlor is "just as he left it for the White House."

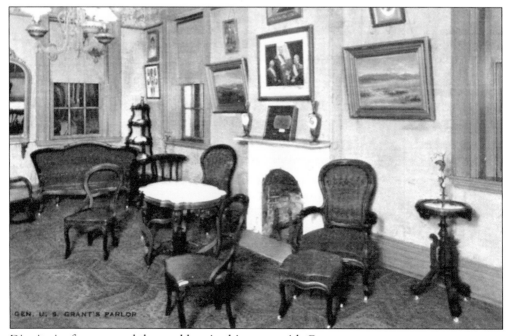

GEN. U. S. GRANT'S PARLOR

Dignitaries from around the world sat in this room with Grant.

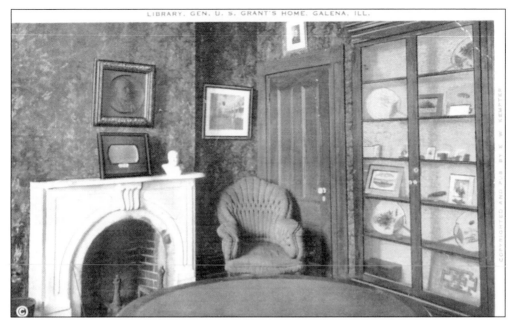

The library was Grant's favorite room in the house and where he spent the most time. The stuffed Victorian chair was Grant's favorite chair. He took it with him to Washington, D.C., and brought it back again. It has been reupholstered to its original state.

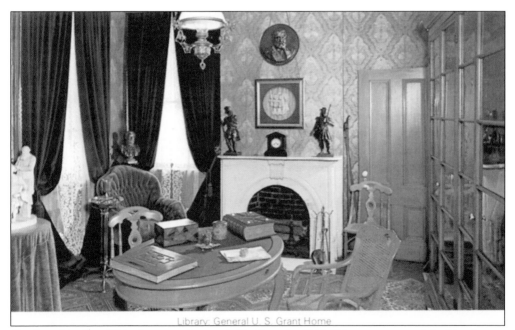

Library: General U. S. Grant Home

On the table sits a Bible that was given to Julia Grant in 1865. There are two original bookcases that are filled with books that belonged to the Grants. In this room, with its original oak furniture, were held many political conferences in 1868. The overstuffed chair and the smoking stand were used by General Grant in the White House. (Photograph by Bob Coyle.)

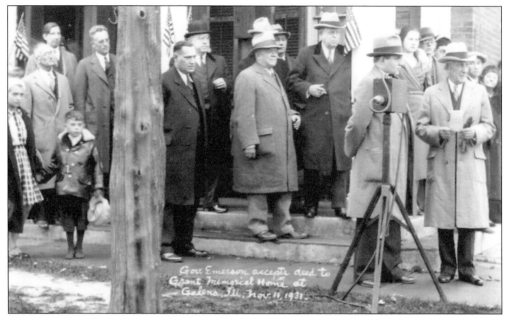

Gov. Emerson accepts deed to
Grant Memorial Home at
Galena, Ill. Nov. 11, 1931.

In 1904, Ulysses S. Grant's children gave the house to the City of Galena "with the understanding that this property is to be kept as a memorial to the late General Ulysses S. Grant, and for no other purpose." Maintaining the Grant's home, however, proved too costly for the city and the Grant Home Association, so in 1931 the city deeded the house to the State of Illinois. Gov. Louis L. Emmerson accepts the Grant Memorial Home at Galena in this picture. (Courtesy of the Greene Collection.)

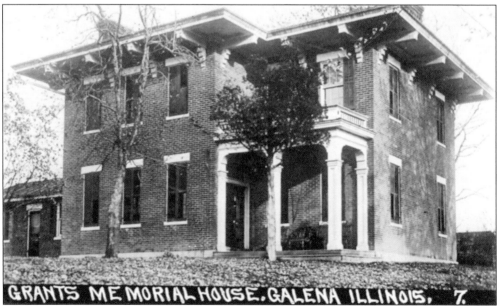

GRANTS MEMORIAL HOUSE, GALENA ILLINOIS, 7.

A thorough restoration project was started in 1955. Considerable research was undertaken as the house was returned to its 1868 appearance. Fortunately much of the furniture used by Grant and his family remained in the house. Restoration of the home was returned to its appearance as pictured in the November 14, 1868, issue of Frank Leslie's *Illustrated Newspaper*.

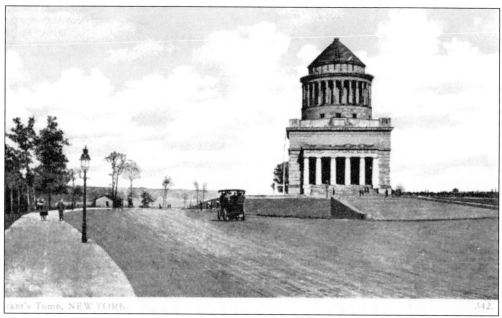

On July 23, 1885, Grant died at age 63 of throat cancer at Mount McGregor, New York. On April 27, 1891, ground was broken for the construction of Grant's Tomb, at Riverside Park in New York City. On April 27, 1897, Grant's Tomb was dedicated. Over the years the tomb was neglected and desecrated. When the citizens of Galena found out, they tried to get his body brought back to Galena. The Illinois State Legislature went so far as to pass a resolution demanding reinterment of Ulysses and Julia Grant in Illinois, if Grant's Tomb were not restored by federal and New York officials charged with responsibility over the site. Under pressure, the government enacted several improvements.

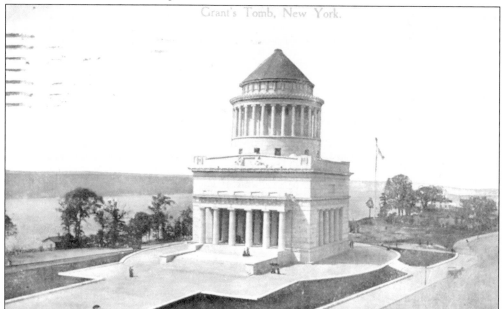

Grant told his son, shortly before he died, that he would like to either be buried in Galena, New York State, or in Washington, D.C.

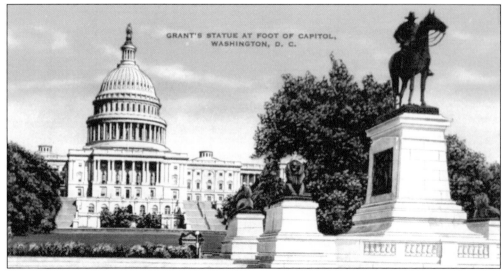

Ulysses S. Grant's statue at the foot of the Capitol Building in Washington, D.C., took over 20 years to complete. At 252 feet long and 70 feet wide, it is the largest statuary group in Washington. Grant is flanked by Union artillery and cavalry (as well as a few lions) and is often described as contemplating the Union troops camped on the Mall during the Civil War. Unknown artist Henry Shrady did an immense amount of research in designing the statue group. The cavalry and artillery groups that flank Grant's statue are particularly impressive. The statue of the lead horse, which Shrady modeled nine times before he was satisfied, has Shrady's thumbprints preserved in bronze. Galena watched with interest because they knew how important horses had always been in Grant's life.

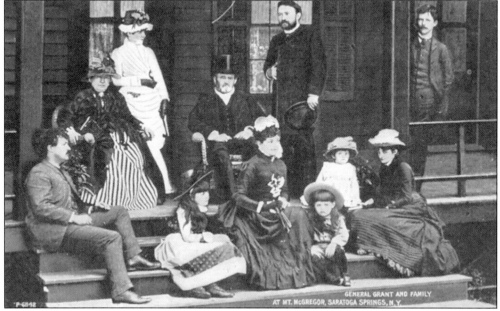

Grant and his family are pictured at Mount McGregor in Saratoga Springs where he died. All the church bells of Galena tolled when their legendary hero was laid to rest. His friends and neighbors filled the Grant family's First United Methodist church where they shared their feelings of personal loss. Several of his close friends spoke feelingly of Grant's life.

Five

PANORAMIC GRANT PARK

It would be hard to find a park that better epitomizes small-town America at its best than Grant Park in Galena. It is situated high over the Galena River. This view captures a spectacular view of 19th-century Galenian architecture. Trains frequently pass beneath the hill along the river's edge. The meandering pathways introduce strolling as a new hobby for the unaware 21st-century passerby. Wherever the eye turns, it is met with a visual feast. The variety of plants, trees, and flowers for every season is a work of love done by community volunteers. The park is a much-used shrine to their legendary hero Ulysses S. Grant. All ages utilize the benefits of this park for the playground, picnics, art fairs, weddings, walking, sight-seeing, and for enjoying the spectacular unmatchable view of downtown Galena and the hillside buildings above it. (Photograph by Bob Coyle.)

GALENA, IL

GRANT

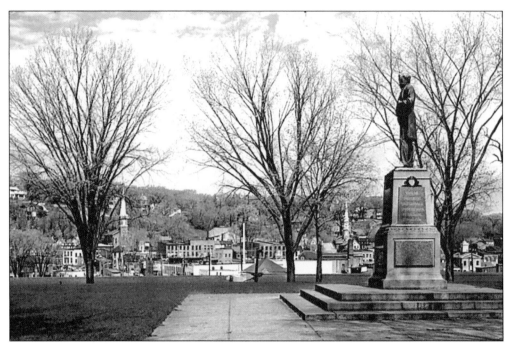

A bronze statue of Ulysses S. Grant was installed in Grant Park; it was donated by H. H. Kohlsaat and dedicated in May 1891. From its lofty perch, the statue continues to look down and oversee all of the activities that take place in the park.

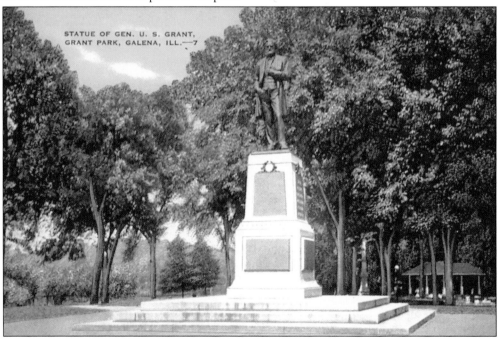

According to legend, when Julia Grant first saw the statue of her husband, she expressed a bit of displeasure with the placement of the former president's right hand. When the sculptor asked if something should be changed, Julia said, "No, leave it as it is, but dear me, I've told that man 20 times a day to take his hand out of his pocket!"

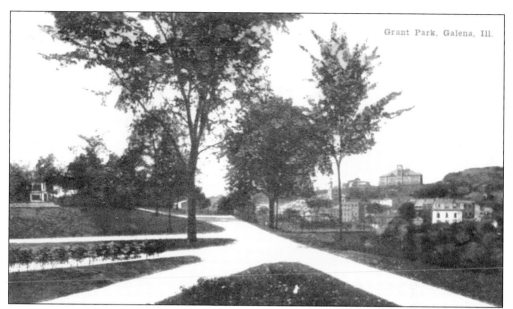

These cards were some of the earliest images of Grant Park probably dating to around 1908. The new high school, constructed in 1906, is seen high on the opposite hill.

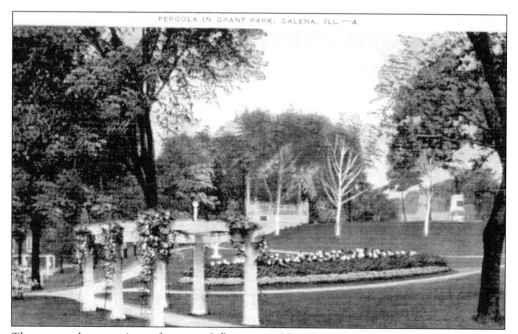

There are a large variety of trees and flowers visible. The gazebo bandstand is half-hidden behind the trees.

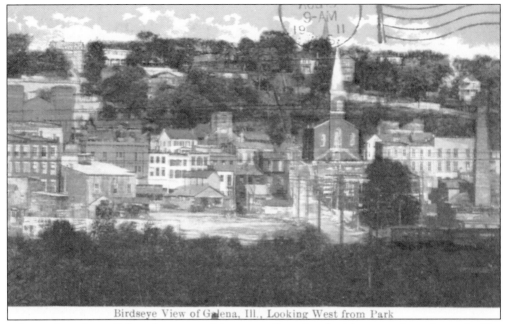

Birdseye View of Galena, Ill., Looking West from Park

It is worth a trip to Galena just to see this outstanding view looking west from the park. The architectural 1850s vision, as seen in this 1911 card, remains basically the same today.

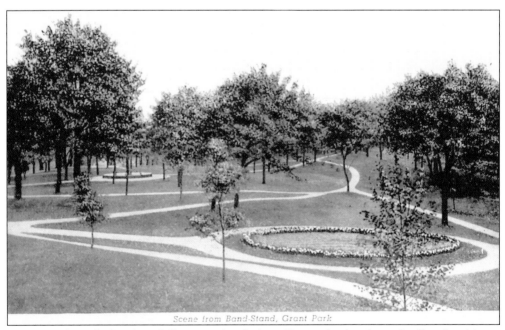

Scene from Band-Stand, Grant Park

This scene from the bandstand illustrates the ideal strolling paths that the park offers the visitors. Benches along the way provide the opportunity to rest and to contemplate the spectacular views. Small-town America does not get better than this.

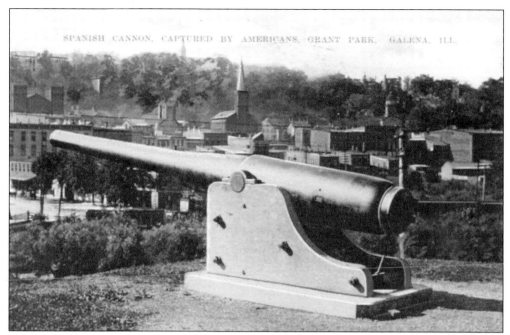

This Blakely gun not only was a participant in the initial engagement of the American Civil War, but it was the first rifled cannon to be fired in combat on the American continent. It is a major piece of history. Originally given to South Carolina by the British the day it seceded from the Union, it was part of the battle at Fort Sumter. This English-made, 3.67 inch Blakely rifled gun literally reverberates with history. The secretary of war authorized the gift of the Blakely rifle to the Grant Park as part of the inauguration of Grant Park and the birthday celebration for Ulysses S. Grant.

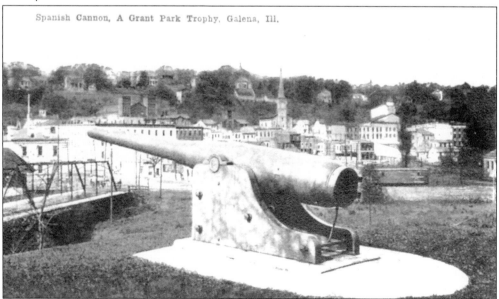

Spanish Cannon, A Grant Park Trophy, Galena, Ill.

Both of these postcards are mistakenly labeled as a Spanish cannon. There is a Spanish cannon in the park that was captured in the Spanish-American war. It has three circles around the barrel of the cannon. This is the Blakely gun.

This 1900 gazebo bandstand is not only pleasing to the eye, but it is well used by a variety of musicians who play in the park for weddings, country art fairs, and numerous other occasions. Classical music, banjo, soft violin, and folk music artists find their way to this bandstand. The music floats out over the park and the Galena River like a melodic fog that eventually covers the whole of downtown Galena. (Photograph by Bob Coyle.)

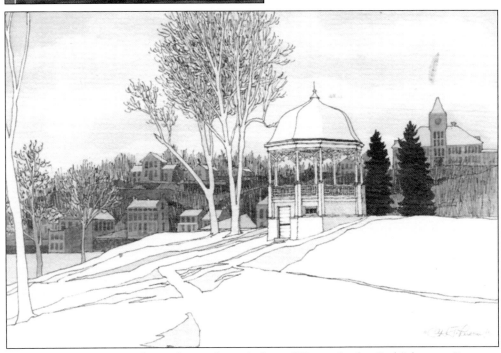

This lovely winter scene shows the gazebo at its best. (Watercolor by Carl Johnson, Courtesy of the Greene Collection.)

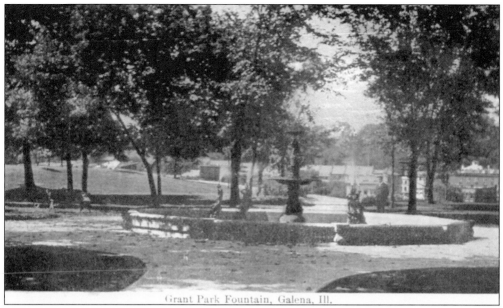

Grant Park Fountain, Galena, Ill.

This European fountain was presented to Galena by the Ladies Auxiliary in May 1891. They raised the money to purchase this European Victorian bronze fountain with a beautiful woman in the center surrounded by four cherub angels. The town was very upset to discover one cherub was missing in the 1990s. They finally hired scuba divers to search the river. They found the angel none the worse for the wear and tear of the watery grave that vandals had given her. The fountain was recently refinished to its original luster. On hot days, children have ignored a small Do Not Swim sign (now gone) to frolic in the fountain's spray. Adults read and rest nearby to the soothing sound of the fountain's waters.

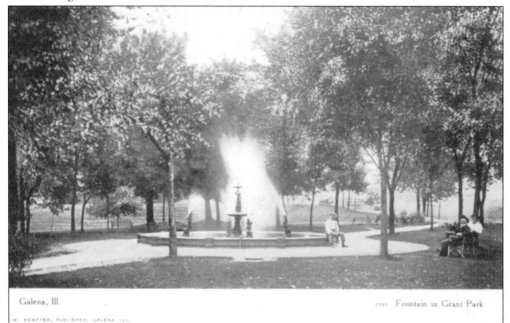

Galena, Ill.

Fountain in Grant Park

W. KEMPTER, PUBLISHER, GALENA, ILL.

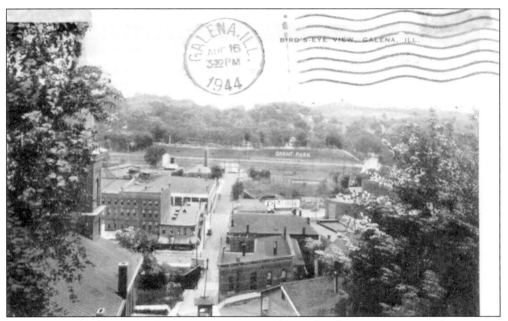

This view is looking east from Prospect Street above the downtown across the river to Grant Park.

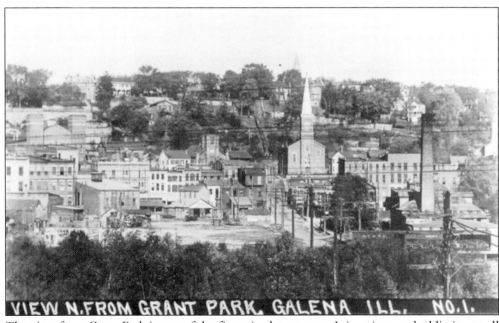

The view from Grant Park is one of the finest in the country. It is unique and addictive to all who see it. One of the major accomplishments of Pres. Ulysses S. Grant included getting the 15th Amendment passed and signing the act to establish the first national park, Yellowstone National Park, in 1872. How fitting that this park be named in his honor.

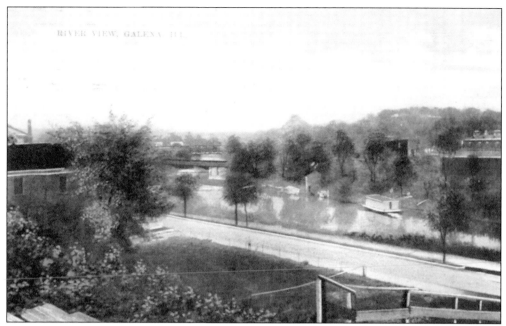

This early image from the edge of the park shows a river view and a sidewalk along the edge of the water that no longer exists. A wooden staircase down to the street is also gone. A rare houseboat is moored across the river.

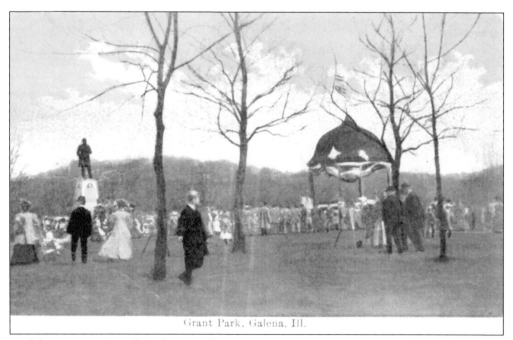

With bare trees and patches of snow still visible on the gazebo roof, people are flocking to Grant Park to welcome spring and celebrate a happening in the park.

The humor of earlier days is defined in colorful, cartoon-like postcards like this one. (Courtesy of the Greene Collection.)

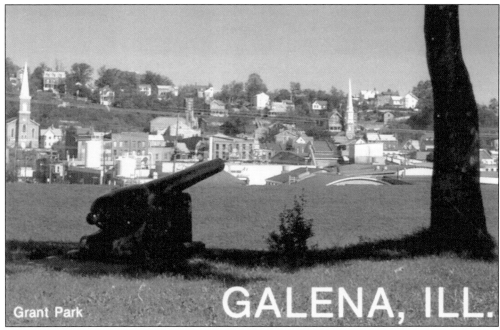

Grant Park's spectacular vista view is a panoramic paradise for camera buffs. There are unlimited opportunities to get creative shots of the horizon. In hopes of capturing a tiny bit of the historic magic that exudes from this small town in northwestern Illinois, tourists flock to this spot with their cameras fired up. (Photograph by Bob Coyle.)

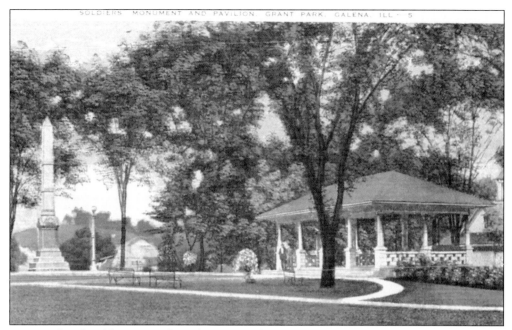

Grant Park is the oldest city park, with a gazebo, fountain, and a pavilion. In the right corner, one can see the covered pavilion, which has entertained thousands of picnickers. Grant Park's Soldiers' Monument is seen on the left corner. It was installed in 1891, with a dignified presentation of the names of the Civil War departed inscribed on the stone.

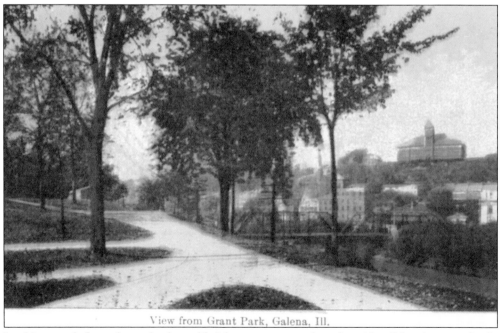
View from Grant Park, Galena, Ill.

Looking south from the park, the red brick structures on the other side of the river are clearly visible in this old image. Grant Park remains the pride of Galena, rich in natural beauty and charm.

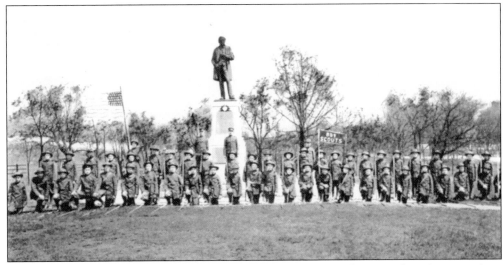

Boy Scouts of America have been coming to Galena to visit Ulysses S. Grant's statue since the early 1900s. The Boy Scouts of America endeavors to develop American citizens who are physically, mentally, and emotionally fit; have a high degree of self-reliance as evidenced in such qualities as initiative, courage, and resourcefulness; have personal values based on religious concepts; have the desire and skills to help others; understand the principles of the American social, economic, and governmental systems; are knowledgeable about and take pride in their American heritage and understand our nation's role in the world; have a keen respect for the basic rights of all people; and are prepared to participate in and give leadership to American society. It is obvious why they come here.

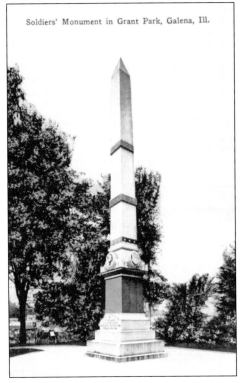

Soldiers' Monument in Grant Park, Galena, Ill.

The Soldiers' Monument was dedicated in 1891 to the soldiers of Jo Daviess County who served in the Civil War (1861–1865), and to their Commander-in-Chief Ulysses S. Grant. It lists the men who died in the Civil War from this county. (Courtesy of the Greene Collection.)

Six

GALENA'S DOWNTOWN

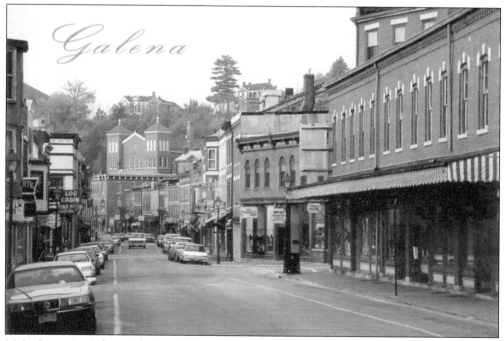

Main Street in Galena is built upon rugged rocky hills. It is rich with history of stagecoach, riverboat, and early mining days of the Civil War era. The original stone houses, rock dwellings, and specialty shops add to its appeal. St. Michael's church, located on Bench Street, appears above Galena's Main Street. The brick facades of the Main Street buildings were chosen as a way to ward off the destruction of the businesses due to fire. (Photograph by Jim Doane.)

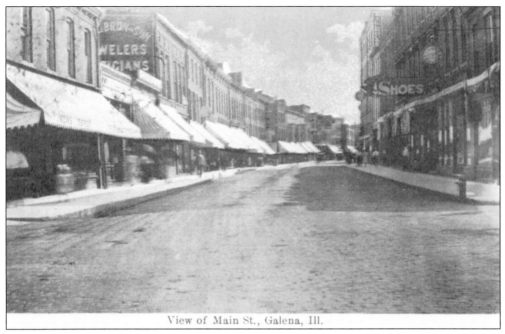

View of Main St., Galena, Ill.

Downtown Galena's Main Street displays matching awnings on each side of the street. The sunny side of the street put its awnings up and the other side took them down. Then as the sun moved, they switched. Rough brick pavement shows no sign of cars, though a lone bicycle is shown.

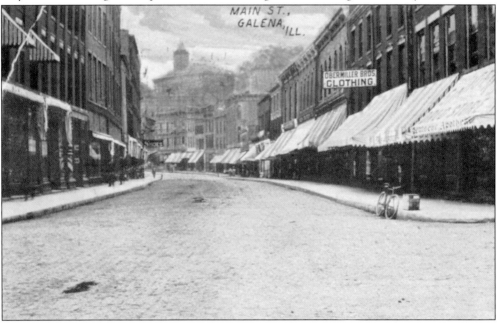

This priceless image is Galena when one could still see empty hills at the edge of town. The Fair Store on the right is the only business with a visible sign.

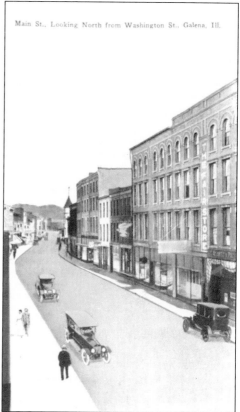

Main St., Looking North from Washington St., Galena, Ill.

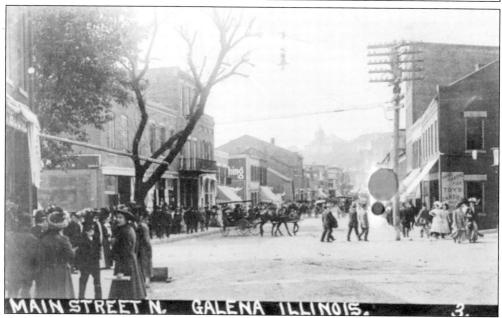

MAIN STREET N. GALENA ILLINOIS.

This 1911 image shows a very active downtown with crowds of people, horses, and buggies. In 1826, Galena had only 150 people. In 1845, Galena had a population of 14,000 people. As of 2007, the city has a population of 3,460. (Courtesy of the Greene Collection.)

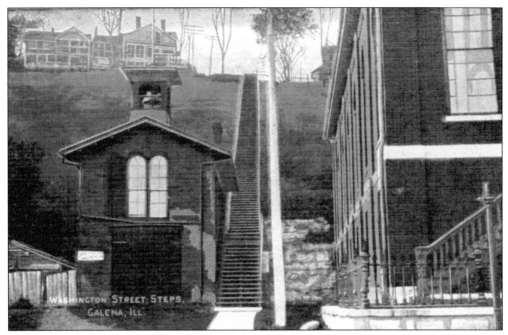

The Washington Street wooden steps lead up to Prospect Avenue. Whenever villagers wanted to get to the higher part of town, they had to climb long flights of stairs. Pictured to the left of the stairs is an 1850 Italianate-style firehouse built on Bench Street. The Old No. 1 Firehouse is believed to be the oldest firehouse of its type in Illinois. Galena's Main Street was devastated by fire on at least three occasions. This firehouse was a thrilling addition to the city.

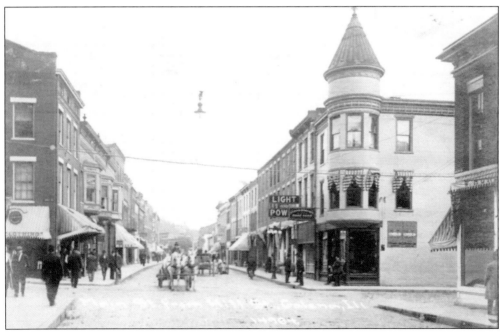

A clothing store and a shoe shop are on opposite corners on Main Street in Galena.

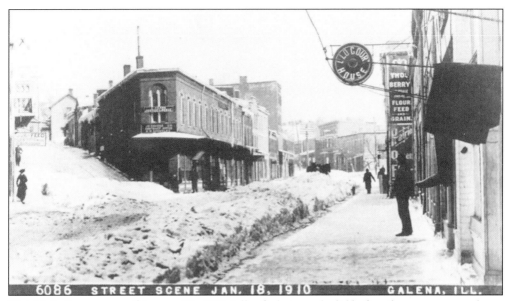

This Main Street scene of January 18, 1910, tells of what people did before there were snowplows. They shoveled the snow into the middle of the streets and cleared away the sidewalks. It looks like it worked unless one wanted to cross the street. (Courtesy of the Greene Collection.)

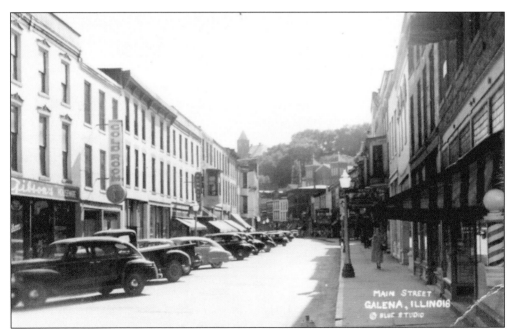

Gibson's Housewares Store and a furniture store are seen with a Cold Room bar in the middle. This was before air conditioning. (Courtesy of the Green Collection.)

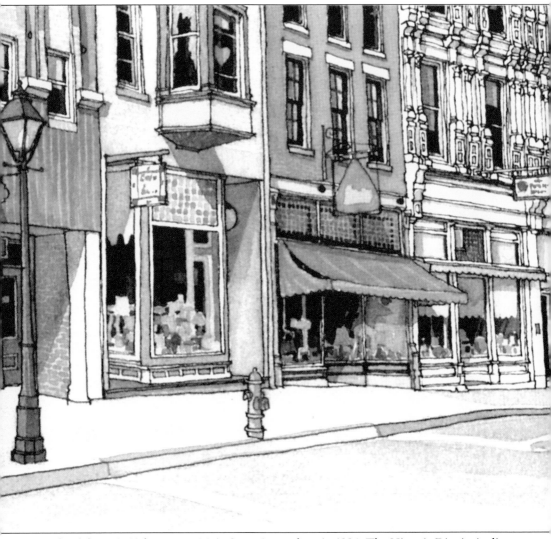

Galena's historic 19th-century Main Street is seen here in 1996. The Historic District is alive once

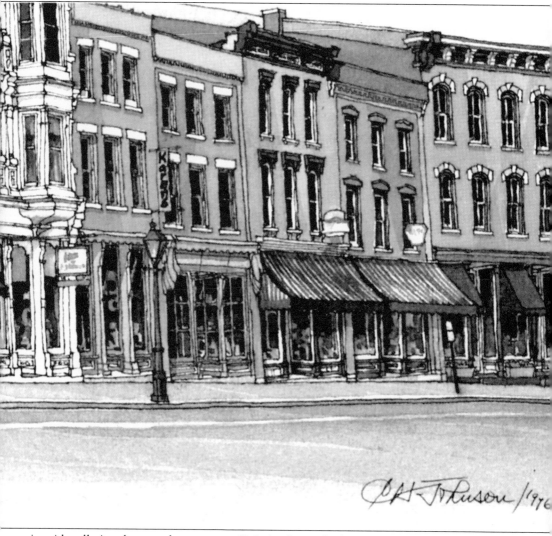

again with galleries, shops, and restaurants. (Painting by Carl Johnson; courtesy Carl Johnson.)

View from Main Street, Galena, Ill.

This 1908 view from Main Street shows the ingenuity of the people who used local materials to make their stone fences and brick buildings.

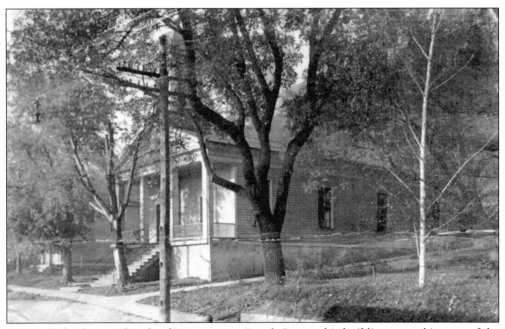

Originally built as a Church of Nazarene on Bench Street, this building was a big part of the landscape of downtown Galena. In this 1912 view, it was still used as a church. It eventually was used by the Boy Scouts and other local organizations for meetings and space to conduct business. On another card, the word Grant is shown above the door. The building was eventually destroyed.

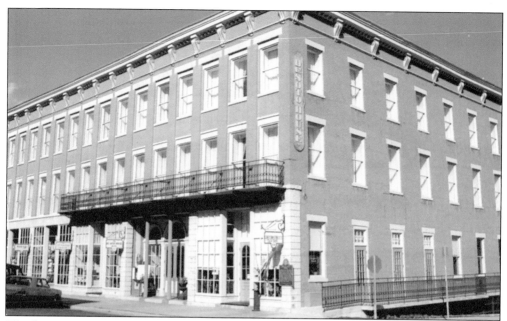

The five-story DeSoto House Hotel opened its doors for business as a hotel on Main Street in 1855 and quickly claimed the reputation as being one of the finest in the civilized world. Once the principal river port of the upper Mississippi Valley, Galena reached its economic peak during the 1850s. With the coming of the Illinois Central Railroad, a group of local investors formed the Galena Hotel Company and built a grand hotel to reflect the growing prosperity of this "Metropolis of the Northwest." It was from a room at the top of the stairs that Ulysses S. Grant planned his campaign to run for president of the United States of America.

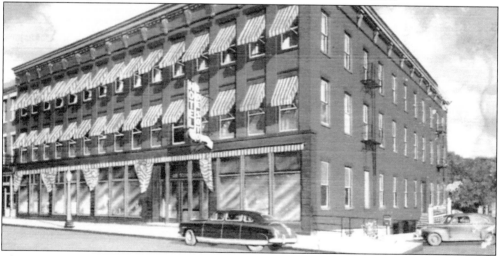

This is a 1914 image of the DeSoto House Hotel. During its long history, the DeSoto House Hotel has been the hub of Galena's social and political activity. Undoubtedly its most prominent visitor was Abraham Lincoln, who spoke from the hotel balcony on July 23, 1856. One hundred fifty years have witnessed many changes at the DeSoto House Hotel. Despite fire, floods, and economic downturns, the DeSoto House Hotel has survived. The top two floors were removed for structural reasons. It continues to welcome Galena visitors and it is the oldest operating hotel in Illinois. (Courtesy of the Greene Collection.)

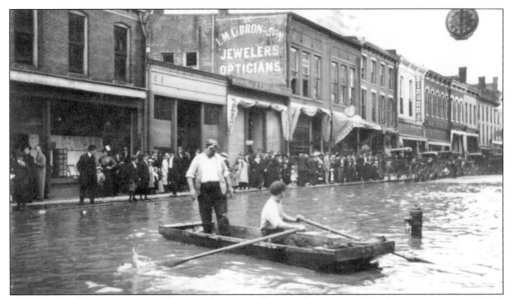

The flood of 1915 was one of many that caused great damage to the downtown area. It left behind several feet of mud and mass destruction to the downtown stores. It required a tremendous amount of work to clean up the mess. (Courtesy of the Greene Collection.)

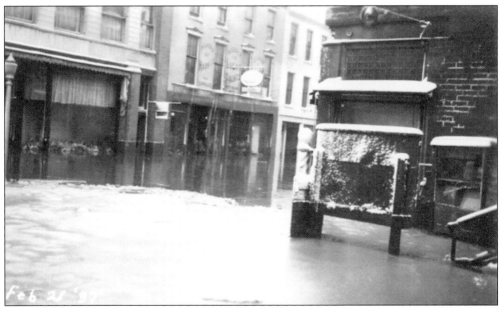

The flood of 1937 was probably the worst. There was six feet of water in the downtown streets. The business people realized that something had to be done, or they would have to move elsewhere. An effort by the local Flood Control Committee and the government led to the Rock Island District Corps of Engineers beginning work on a flood control project in 1948. New storm sewers as well as a pumping station were added. An 18-foot concrete wall and a manually operated gate made a huge difference in a sense of security to the people of Galena. (Courtesy of the Greene Collection.)

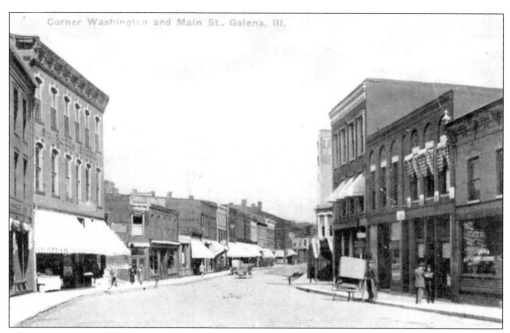

This 1913 postcard shows only horse and carriage traffic on Main Street. There is an ice cream parlor on the left. Awnings are in full use.

Grasping opportunities in GALENA

Fun postcards like this 1912 image were popular with most folks. They were used to send greetings and news. People used words differently. "To-morrow" and "to-day" were written with dashes. They began with "Dear Brother," or "Dear Sister," which was common instead of using the person's actual name. (Courtesy of the Greene Collection.)

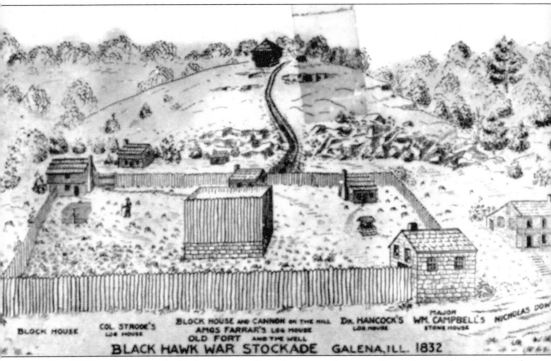

BLOCK HOUSE COL. STRODE'S BLOCK HOUSE and CANNON on the hill Dr. HANCOCK'S WM. CAMPBELL'S NICHOLAS DOW
 LOG HOUSE AMOS FARRAR'S LOG HOUSE LOG HOUSE MAJOR STONE HOUSE
 OLD FORT and the well

BLACK HAWK WAR STOCKADE GALENA, ILL. 1832

The Old Stockade was built downtown from huge oak logs cut from the nearby virgin timber around 1828. It had a stone foundation which helped to give it more stability. The Old Stockade was used as a refuge for the pioneers during the Black Hawk War. A large wooded fort was built around it. When the Native Americans threatened the area, hundreds of people rushed to the fort. They stayed for three seasons, jammed together like animals, fearful for their lives. Scarlet fever hit the fort in those crowded conditions and took many lives. Chief Black Hawk never did attack the fort. When he was captured, the people were happy to return to their humble little homes. The Old Stockade is being preserved as one of Galena's old landmarks and it is open to the public.

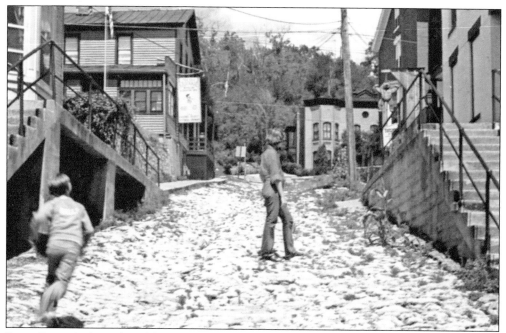

Perry Street is the only cobblestone street remaining in Galena. It leads to the Old Stockade and an underground refuge that was used for protection during the Black Hawk War of 1832. (Photograph by Bob Coyle.)

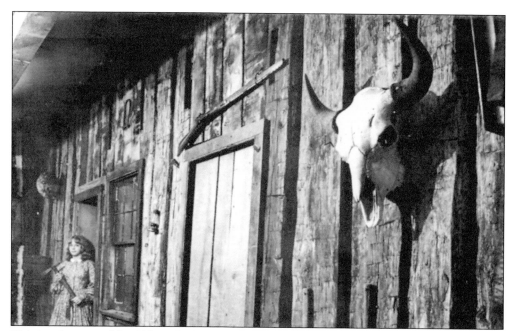

This is a close-up of the Old Stockade's heavy oak log walls that offered protection to the pioneers when they hid from the Native Americans.

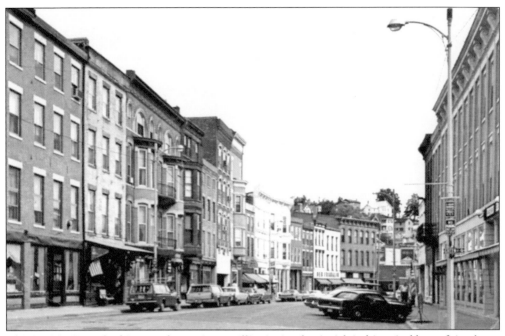

This is Main Street looking north at a pioneer Illinois city that is rich in historical lore of riverboat, stagecoach, and the early mining days of the Civil War era.

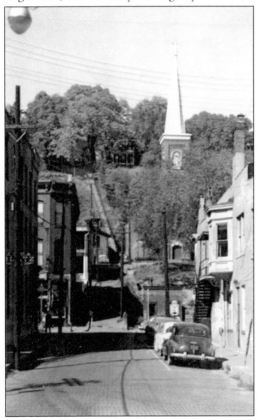

Looking up on Washington Street, one can see stairs connecting three street levels. The church spire is where Ulysses S. Grant worshiped. Galena's oldest fire station can be seen opposite the church.

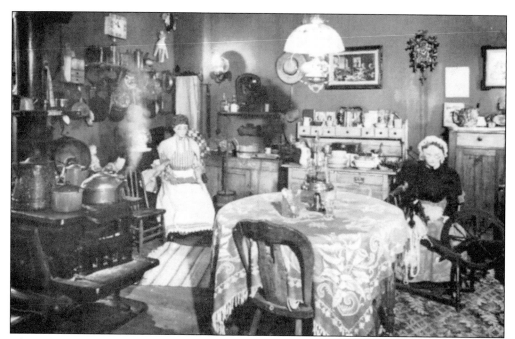

This Old General Store is preserved as it was for over a hundred years. The proprietor was Marie Duerrstein.

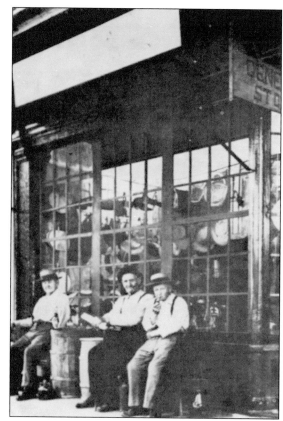

Men outside the Old General Store are enjoying a chat while they sit on Marie Duerrstein's barrels. (Courtesy of the Greene Collection.)

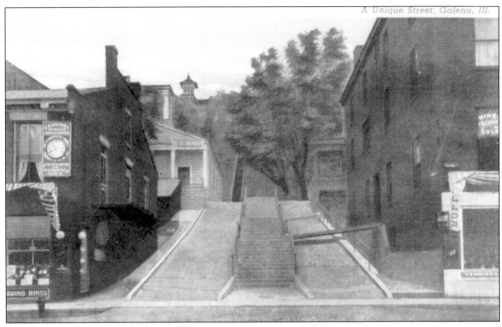

This is an earlier and later version of the steps that lead from Main Street, to Bench Street, to Prospect Street at the top of the hill. This is a most unusual set of steps that look like they go straight up to heaven.

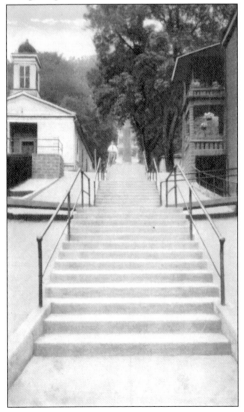

The only way to get around Galena before automobiles was to do a lot of climbing. Young students had to climb these stairs everyday to go to high school. They ran down the steps to go home for lunch, then they climbed them again for afternoon classes. They came back down at the end of the day, for a total of 700 steps climbed per day.

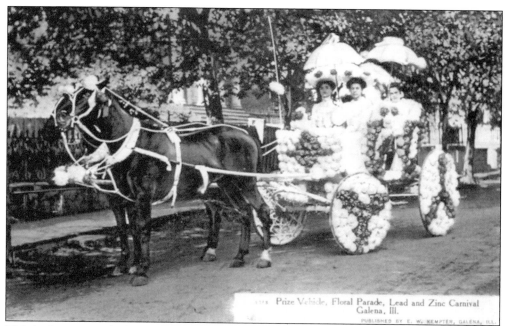

This is the prize vehicle in the floral parade for the Lead and Zinc Carnival. The dirt street looks like it is Bench Street. Galena has always been a city of parades. This had to be one of the first.

A huge parade is in progress. The women are dressed in long white dresses. Everyone is wearing a hat. (Courtesy of the Greene Collection.)

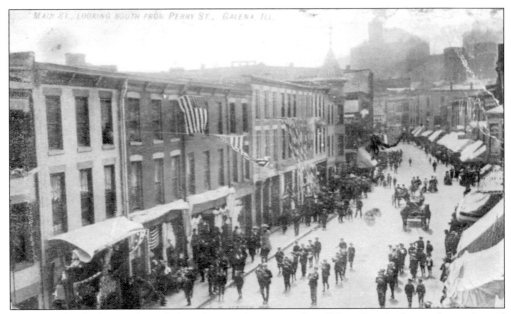

The Fourth of July Parade in Galena is a much-treasured tradition. Bands, fireworks, and good food are a part of the day. This early image is looking south from Perry Street at the oncoming Main Street Parade. There are two horse and buggies and a band followed by people in the street on foot.

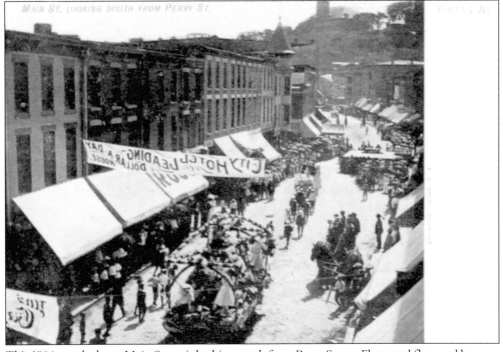

This 1906 parade down Main Street is looking south from Perry Street. Floats and flags and banners are evident. The City Hotel is offering a room for $1 a day. (Courtesy of the Greene Collection.)

GALENA FAIR,
AT GALENA, ILLINOIS,
SEPTEMBER 30, OCTOBER 1, 2 & 3, 1890.

E. G. BUTCHER'S

Aerial, Vehicular, Equestrian Gymnasium, and Roman Standing Races Daily.

Special Attractions and Special Races Daily.

EXCURSION RATES ON ALL RAILROADS.
SPECIAL TRAINS RUN DAILY.

EUGENE W. MONTGOMERY, President. *FRANK BOSTWICK, Secretary.*

This rare card gives quite a bit of information and insight into the Galena Fair activities. Trains probably came from Chicago for this three-day event. (Courtesy of the Greene Collection.)

No mention of Galena, Illinois, is complete without an image of Ulysses S. Grant and his home.

Once taken for granted that one could catch a train to Galena, it is now a rare occurrence. Men used to work in Chicago and take the train home to Galena.

Seven

ARCHITECTURAL DELIGHTS

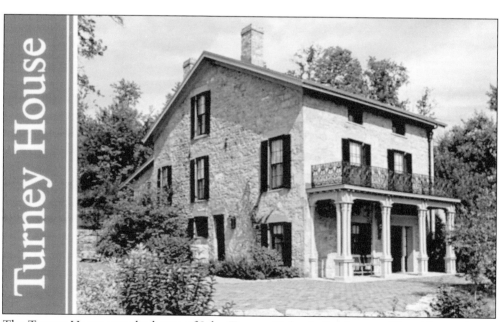

The Turney House was the home of John Turney, Galena's first lawyer. The old stone house has been meticulously restored to reflect its historic past. The stone layer who originally built this house did an amazing job using local stone. The building was open to the public for years, and the visitors could see Turney's primitive law office, plus living quarters appointed with fine federal furniture. It is now operated by a local law firm with law offices. (Photograph by Bob Coyle.)

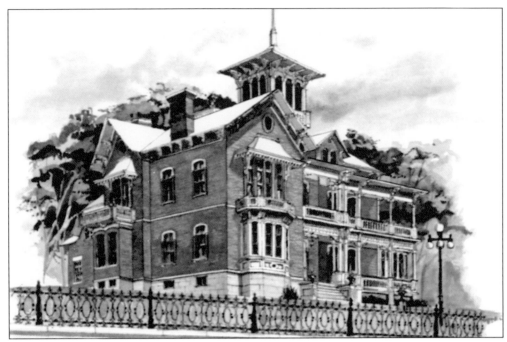

The Belvedere is the largest mansion in Galena. It was built in 1857 for H. Russell Jones, the owner of a steamboat line and ambassador to Belgium. It was restored in 1963. At one time, it was used as a restaurant with fine dining in the spacious Victorian rooms. It is open to the public for tours.

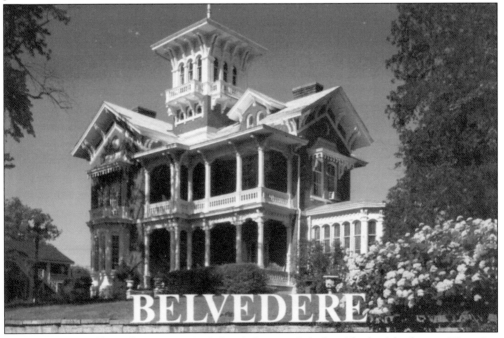

This Italianate villa–style mansion is Galena's largest. It is furnished with elegant Victorian furniture and appointments. It is a magnificent sight to all who cross the Highway 20 bridge. (Photograph by Bob Coyle.)

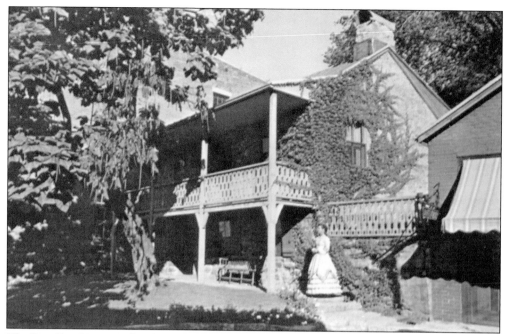

The Dowling House is the oldest house still standing in picturesque Galena. It was built in 1826 of native limestone by pioneer merchant John Dowling. At the time it was built, there were 195 homes, warehouses, and shops in the rapidly growing city. This handsome stone structure has been restored as an original primitive dwelling and the Old Miner's Trading Post using authentic furnishings. It is open to the public.

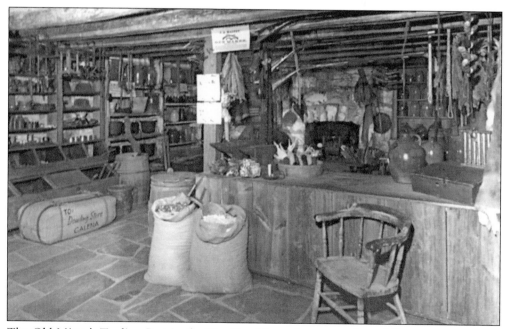

The Old Miner's Trading Post in the Dowling House is open to the public. It is on Diagonal Street. Inside one will find what the miners used and needed for their daily survival.

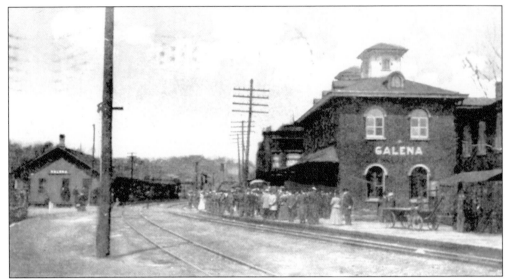

The Illinois Central Railroad Depot was built in 1857 on Park Avenue and Bouthillier Street facing the Galena River. The depot was serviced by four of the leading railways of the northwest, namely, the Illinois Central, the Burlington, the Great Western, and the Chicago and Northwestern Railways. There was a ladies' reception room and dressing room with a special ladies' entrance. The gentlemen's reception room was largest. The upstairs was used as a dwelling for the station master and his family. It is now the tourist information center. This 1911 shot illustrates the heavy use this depot has always known.

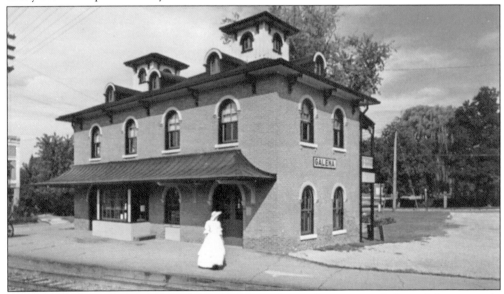

It was from this station that Ulysses S. Grant and eight Civil War generals from Galena went in 1861 to help Pres. Abraham Lincoln stop the uprising. It was into this station that Grant returned in 1865 after the Civil War. The newspapers said that 25,000 people turned out waving flags to welcome him home. Grant and his family left from this station to go to Washington when the nation elected him the 18th president of the United States. The depot today is a feast for the eye and a delightful stop where the visitor can get current information about the area. (Photograph by Bob Coyle.)

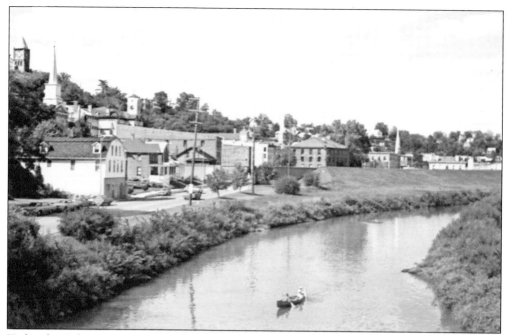

Today the Galena River is ideal for canoeing. Small motor boats cautiously navigate the waters. The historic landscape remains reassuringly similar, but the lively river activities are a thing of the past. The romance of the river is forever present as the reflection of the old buildings bounce off the sunlit waters and cast a spell of another place in time. (Photograph by Bob Coyle.)

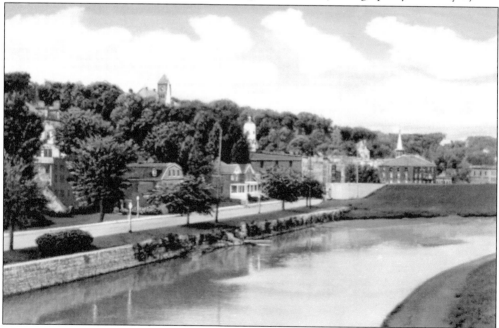

The early miners and settlers enjoyed the scenic view of historic Galena with as much joy as some do today. The buildings were left untouched when the economy declined because no one had enough money to take them down. This turned out to be a blessing in disguise. Over 85 percent of Galena is listed on the National Register of Historic Places.

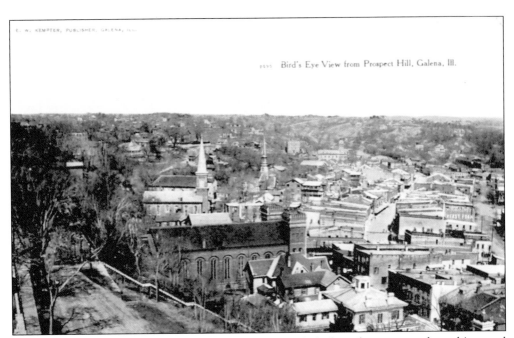

E. W. KEMPTER, PUBLISHER, GALENA, ILL.

Bird's Eye View from Prospect Hill, Galena, Ill.

Looking down from the top of the hill on Prospect Street is the best chance to see the architectural variety of historic Galena. Stone and brick walls and houses nestle into the hillside just like they did in the 1800s. The town attracts artistic types who have lovingly restored each building.

Greetings from GALENA ILLINOIS

GEN. U.S. GRANT'S HOME BEFORE THE WAR

Prospect Street is 270 feet above the city of Galena. It is a street of old Victorian mansions that stand guard over the town like sentinels in the night. The dirt path is now blacktop but still narrow and scary for two-way traffic.

This 1911 Christmas greeting from Galena captures nature's architectural beauty as found in a sunset a few miles down river where the Galena River joins the Mississippi River. (Courtesy of the Greene Collection.)

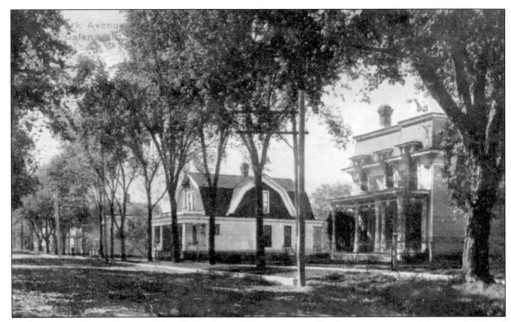

Park Avenue is on the east side of the river. It is an avenue in the true sense of the word. Lined with trees and verdant lawns, it speaks of days long gone when people drank lemonade on the wide porches of these welcoming Victorian homes. Pillars, turret towers, and high chimneys combine to tempt any real estate buyer.

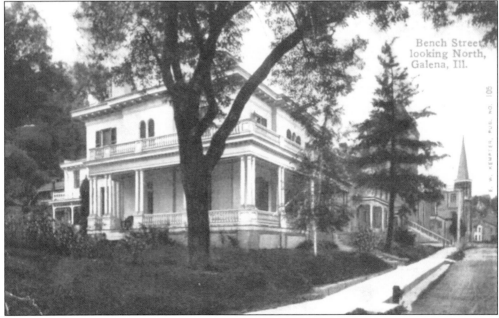

Bench Street is one block above Main Street. It is a street with several churches and appealing homes like this one. Porches, pillars, and railings provide an alluring picture that is reminiscent of the old southern way of life.

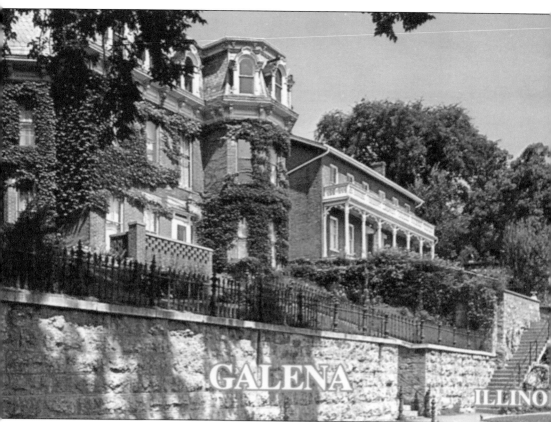

This card is of two pre–Civil War homes built with what is called steamboat architecture. They are set high above Prospect Street and the whole city, which lies in front of them. A staircase can be seen going down to Prospect Street. The back of the houses would be on High Street. The house on the left is known for its ballroom on the top floor. The hooks where ladies hung their capes while they danced can still be seen in the walls. The ivy-covered brick walls hold many stories of moonlight dances.

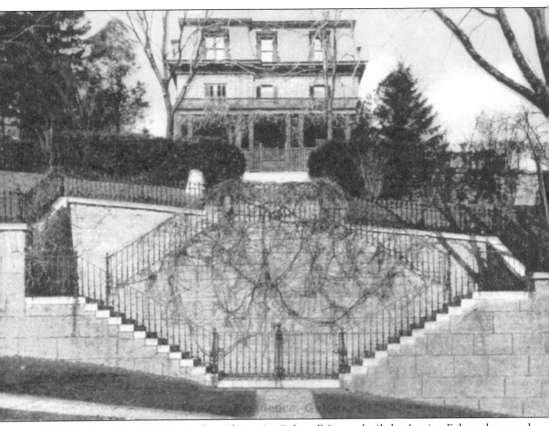

This 1910 card is titled "typical residence in Galena." It was built by Lucius Felt, a dry goods mercantile business owner, in 1874. This three-story house on Prospect Street shows the double staircase that leads from Prospect Street up to the mansion. It was known as Felt's Folly. The house is in the Second Empire style that was common in Ulysses S. Grant's time period. The early settlers overcame the hardship of the steep hills in Galena by laying stone and brick paths and staircases all over town.

Eight

CHERISHED
PUBLIC PLACES

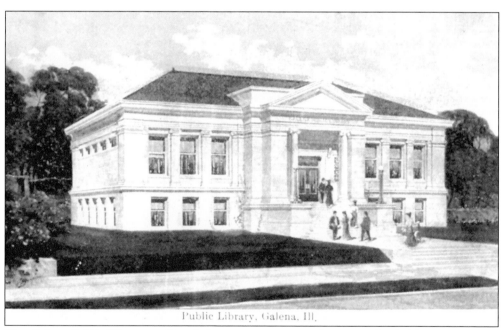

Public Library, Galena, Ill.

The Galena Public Library on Bench Street was constructed in 1908, funded by the Carnegie Foundation and B. F. Felt estate. Sitting on the edge of Bench Street, it allows for a fine view of the Galena River. Looking more like a college campus building than a small town library, this building is a proud addition to the culture of the community. The basement holds many historical photographs and newspaper clippings, along with genealogy findings.

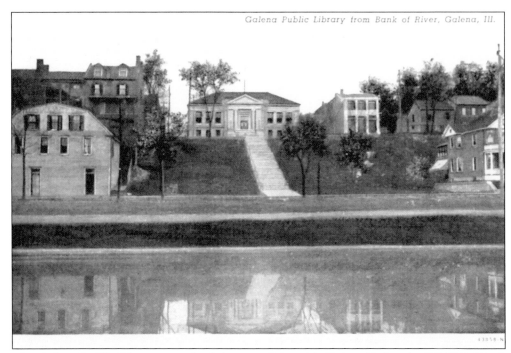

The Galena Public Library steps lead down to Riverside Drive. Today the VFW Soldier's Monument sits at the bottom of the stairs. The locals gather here on Memorial Day to honor the veterans from World War I, World War II, the Korean War, and the Vietnam War. The Galena River sits at the foot of this base of knowledge.

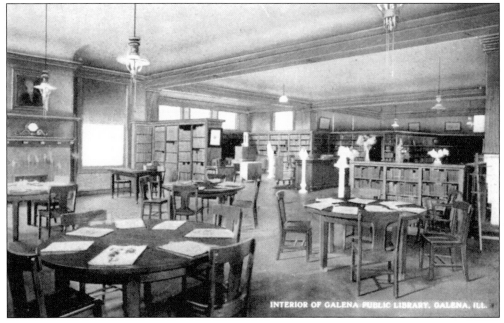

The interior of the Galena Public Library includes a fireplace and plenty of leather chairs, though some of these original pieces of furniture are still there. The openness gives an appealing feeling of the 1930s. (Courtesy of the Greene Collection.)

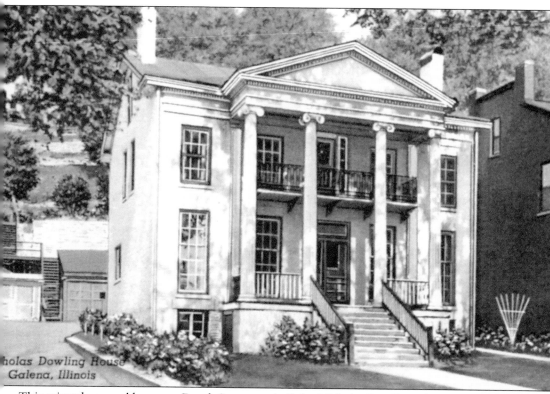

Nicholas Dowling House
Galena, Illinois

This privately owned home on Bench Street was built by Nicholas Dowling, the son of pioneer John Dowling, in 1847. Years have enhanced its beauty, and in a survey by the Department of Interior this was among the early homes of Galena to be acknowledged. Author Janet Ayer Fairbanks made it the home of Abby Delight, the heroine in her novel *The Bright Land*.

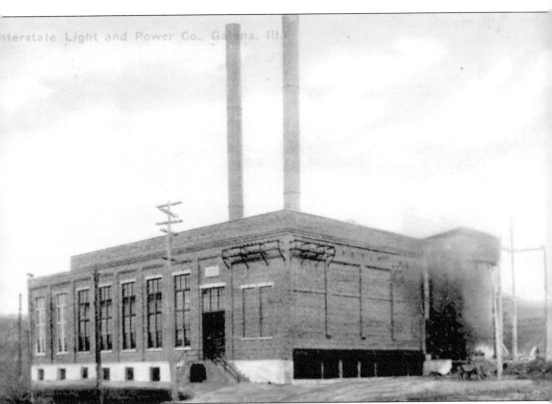

This card boasts that, "here can be found one of the largest Electrical Plants in the country. It is known as the Interstate Light and Power Company and was erected at a cost of $1,500,000. Its light and power is carried for a distance of 100 miles or more, taking care of many of the cities and towns of northern Illinois and southern Wisconsin, and supplying power to the numerous lead and zinc mines throughout the entire mining district."

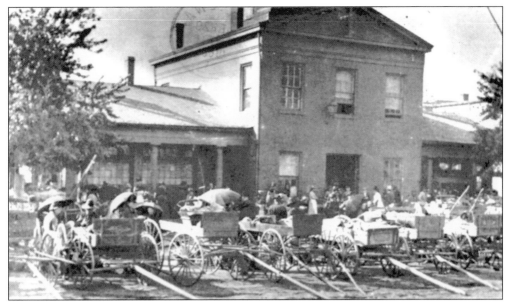

This Old Galena Market House was erected in 1845. It opened in June 1846. This Greek Revival structure is the oldest market house in the Midwest and is a historical landmark of state and national significance. Such buildings were centers of commerce, community, and civic activities in the past two centuries. Slaves were bought and sold here. (Courtesy of the Greene Collection.)

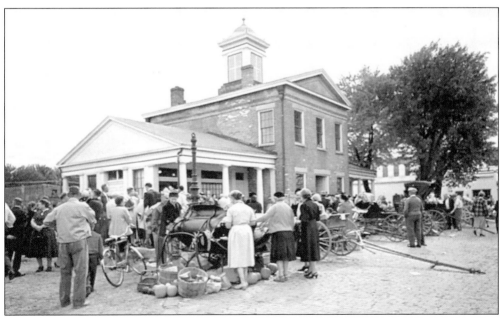

This Old Galena Market House is a state monument that is as actively used today as it has been since 1846. Fresh produce is brought in from the rural areas and a farmer's market takes place here every week during the summer. Inside the space is used to display a revolving exhibit of interest for the community and tourists. At an earlier time, it was used as a jail. Locals tell about one poor woman who was thrown into an underground holding tank to sleep it off. She drowned when the floodwaters rushed in during one of Galena's many floods.

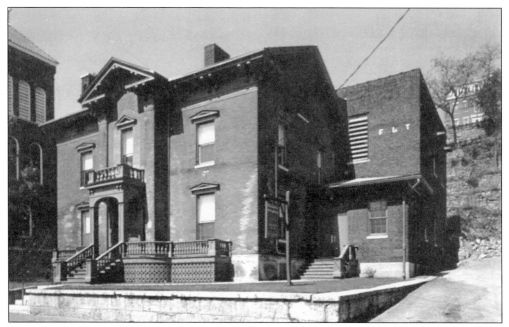

The historic Daniel R. Barrows House at 211 South Bench Street is the museum and the Galena/Jo Daviess County Historical Society headquarters. Built in 1858, a large auditorium was added in 1922 by the Odd Fellows. The museum contains exhibits and thousands of artifacts that explain Galena's unique history. It is open year-round.

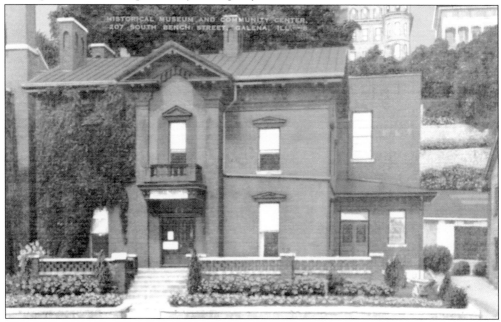

Galena, intensely history conscious, stores relics characteristic of the domestic and industrial life of early days, in one of the largest and most dignified brick structures in Galena, the Galena/Jo Daviess County Historical Society. This was formerly one of the old mansions of the town. An addition to the building that consists of many large rooms, one 40-by-80-feet, was added at a cost of $40,000. One large room is used to sell historic-themed books.

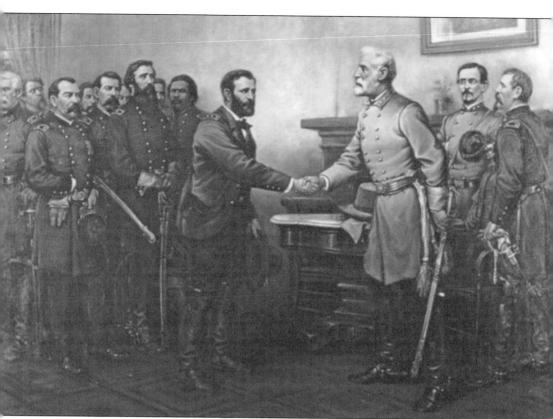

This magnificent life-size painting called "Peace In Union," was presented to the City of Galena by a former Galenian, H. H. Kohlsaat of Chicago, in 1895. It was painted by Thomas Nast, the greatest artist of the Civil War period, and depicts the surrender of Gen. Robert E. Lee at Appomattox on April 9, 1865. The painting is on exhibit where it is kept in the Galena/Jo Daviess County Historical Society. Also in the art room can be seen the portraits of the nine Galena generals who took part in the Civil War.

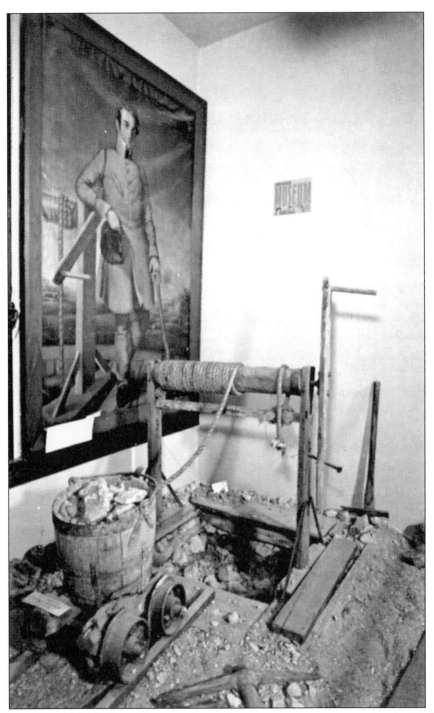

A portrait of Hezekiah H. Geer, pioneer miner and entrepreneur, oversees a miner's windlass on display at the Galena/Jo Daviess County Historical Society's museum. This primitive method was used to pull buckets of lead ore up from the tunnels of the mine. Geer used a windlass many times before he struck it rich and became one of the wealthiest men in the country. (Photograph by Bob Coyle.)

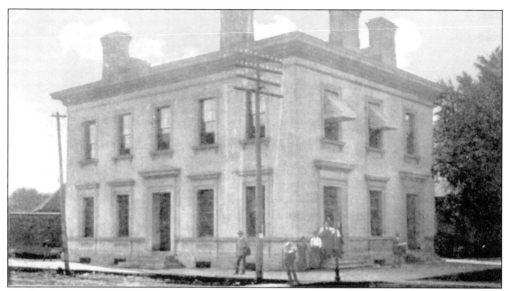

Ely Parker, part Seneca Indian, was appointed superintendent of construction for the United States Customs House in 1857 in Galena. Parker, a civil engineer and a general in the Civil War, was later a member of Ulysses S. Grant's staff. The Customs House, built to register Upper Mississippi River steamboat cargoes, was also the new post office. Today it is the second oldest continuously owned and operated post office in the nation. At the time this classically designed building was erected, the river was so wide that riverboats could pull up to its windows to conduct business. When the basement of the post office was dug and leveled, Parker laid "pigs" of lead all over the ground. He left them there over the winter. In the spring, the concrete was poured over them. The foundation is so firm, it has never cracked.

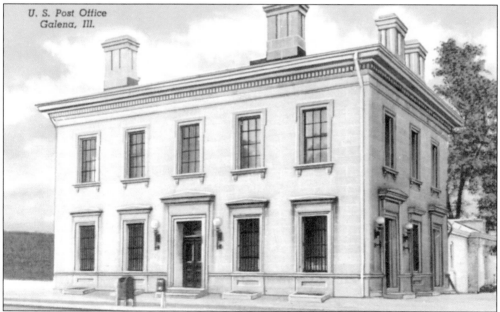

U. S. Post Office
Galena, Ill.

When the post office first opened, the men and women of Galena came to party inside the new building. They dressed in their finest attire. They were thrilled to have such a stately post office in which to pick up their mail. The building is as popular today as ever with the locals.

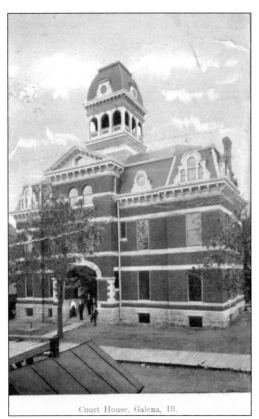

The Jo Daviess County Courthouse on Bench Street was designed by Fr. Samuel Mazzuchelli. It was started in 1839. It was here that Ulysses S. Grant and his generals met and held meetings in 1861. Here soldiers enlisted and Grant presided at the second meeting. Here all the great lawyers of Galena tried their lawsuits. John Taylor was convicted of murder in this building and later hanged on Hangman's Mound in the presence of 5,000 people. He was the first and only person hanged in Jo Daviess County. (Courtesy of the Greene Collection.)

Court House, Galena, Ill.

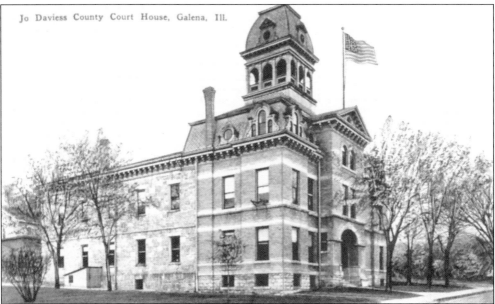

Jo Daviess County Court House, Galena, Ill.

The Jo Daviess County Courthouse had a new facade built in 1900, but the original stone building can be seen from the north and south sides of the structure. Father Mazzuchelli was paid $100 to supervise the architectural work of the building. It took five years to build, and the final price was twice the original anticipated cost.

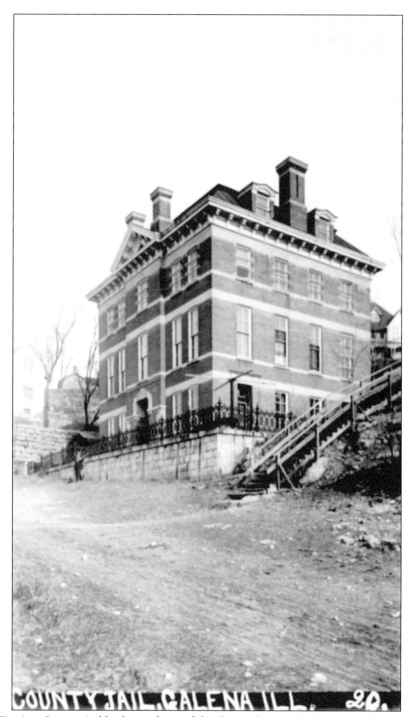

COUNTY JAIL, GALENA ILL, 20.

This Jo Daviess County Jail looks too beautiful to be a jail. It was built on Meeker Street, at the site of an old jail that was destroyed by fire in 1878. The first and second stories were used as the jailor's residence. The third story was the prison. A sheet of iron covered the floor. Today the building is restored with a bright red slate roof that is easily visible throughout the area. (Courtesy of the Greene Collection.)

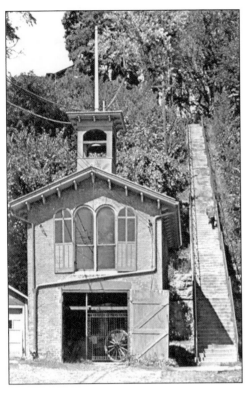

In 1851 an Italianate-style firehouse was built on Bench Street. The Old No. 1 Firehouse is believed to be the oldest firehouse of its type in Illinois. The Galena Volunteer Fire Company was organized in 1830. Inside the firehouse can be seen a hand-drawn and manually operated 1855 pumper. The Washington Street steps ascend from Bench Street, to Prospect Street, and on to High Street. The building has been restored to its original status.

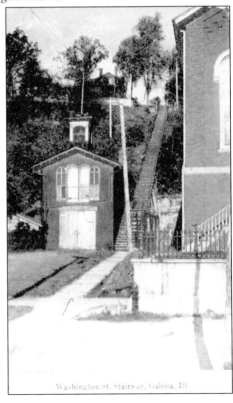

Washington St. Stairway, Galena, Ill.

Nine

A MOST UNIQUE
HIGH SCHOOL

Winter Scene, Galena, Ill.

This rare 1912 postcard shows a lovely winter scene of the Galena High School perched high on the top of Prospect Street. The school stands watch over the whole city and Galena area. Tourists always ask, "what is that building?" They do not expect to hear it is the old high school. Today it is the Galena Green Condominiums. The building, however, holds many warm memories for the community—memories that happened a long time ago.

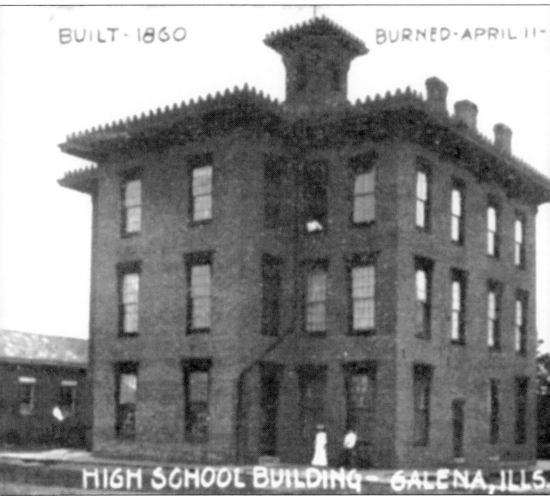

BUILT · 1860

BURNED · APRIL II

HIGH SCHOOL BUILDING — GALENA, ILLS.

This is the only known photograph of the original high school building that was built in 1860, the same year that Ulysses S. Grant moved to town. It was a stately building with many windows and a fancy roofline. The students diligently climbed 175 steps twice a day to go to school. It was a school building that any student would be proud to attend.

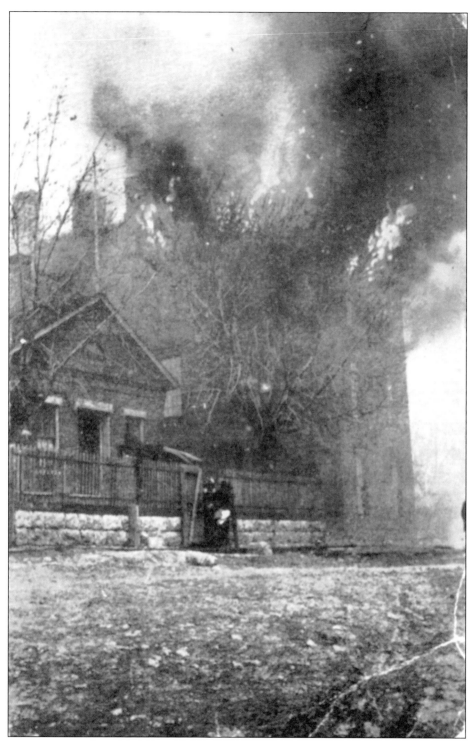

A rare postcard photograph says "old high school burning" across the top of it. The school burned on April 11, 1904. It had to be one of the saddest, most devastating days for all of Galena. People stood helpless as they saw their schoolhouse burn.

A 9791 Galena, Ill. from High School Hill. *1-18-06* 7-cy arrive
esterday and we were awfully surprised
we had company last night until mi
ight and were all out to dinner toda

This 1906 view is taken from the high school hill, which has always been a favorite spot to stop and look at the vista view below. Today people still make the steep climb, but most drive their cars to this appealing place. They linger and wonder what life was like when the city below had 14,000 people living here.

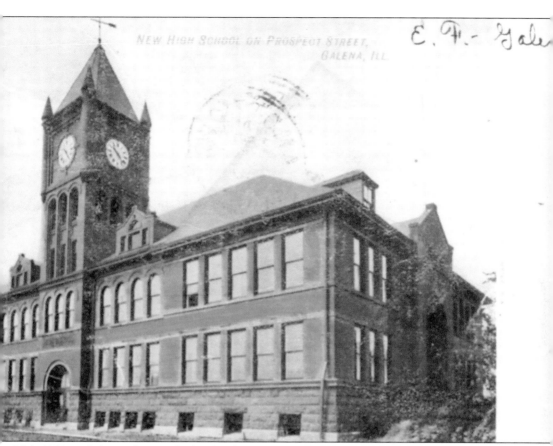

This 1908 card shows the new high school complete with a clock bell tower. The building was built in 1905, but at the time of construction there was not enough money to pay for the planned bell tower. Margaret Gardner had been a much-loved Galena teacher for 35 years. She thought that if each of the students could donate a small sum of money, the school would have enough funds for a clock tower. The fund-raiser was successful, and the clock tower was constructed. The clock kept time for the whole community, and every day the bell rang to announce that school had begun.

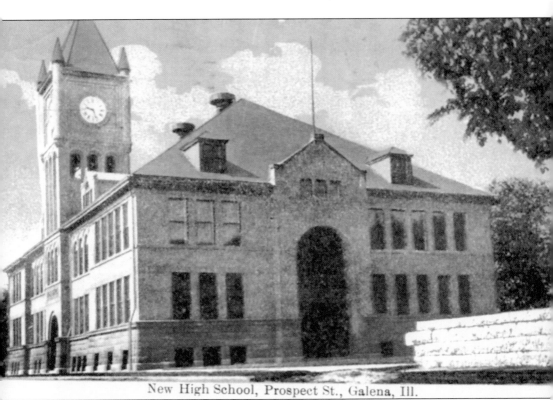

New High School, Prospect St., Galena, Ill.

The local children were getting their high school education in this school in this 1911 image. There is a large U-shaped door looking out from the side of the building. There are three stories with many windows. There is a front door below the clock facing east and the city below. The brick exterior has been carefully laid to last more than a century.

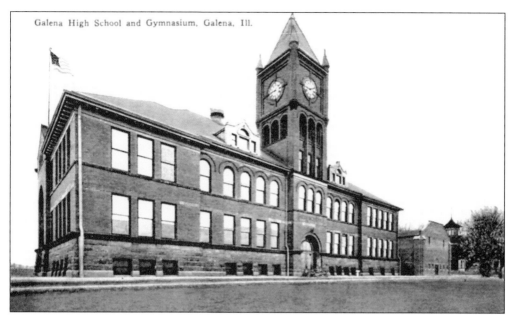

The Galena High School gymnasium is clearly seen to the right of the schoolhouse. It was an advanced idea to offer a place for the students to have physical activity. Unfortunately it was taken down. Eventually, it became a parking lot when the school turned into a condominium project.

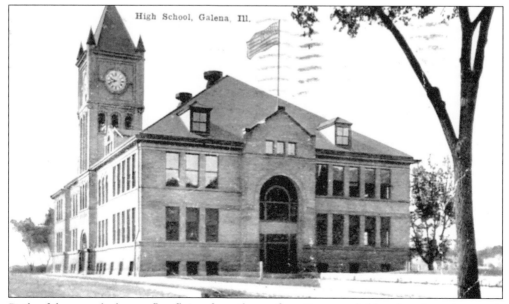

High School, Galena, Ill.

Both of these cards show a flag flying from the rooftop. It was probably taken down because it would have been too difficult to get to it.

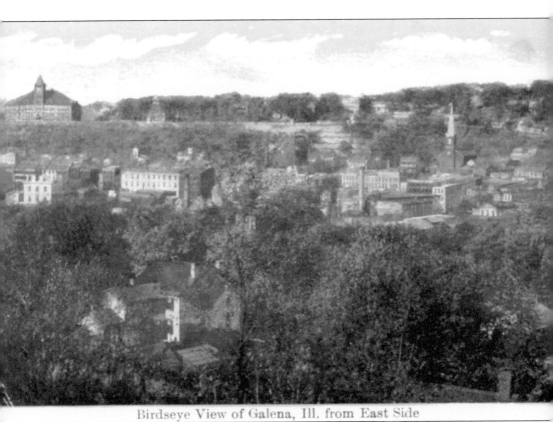

Birdseye View of Galena, Ill. from East Side

From the east side of town, this early view of the Galena High School had to be an inspiring sight. Today it is still awesome to behold this magnificent building, which overlooks all of Galena.

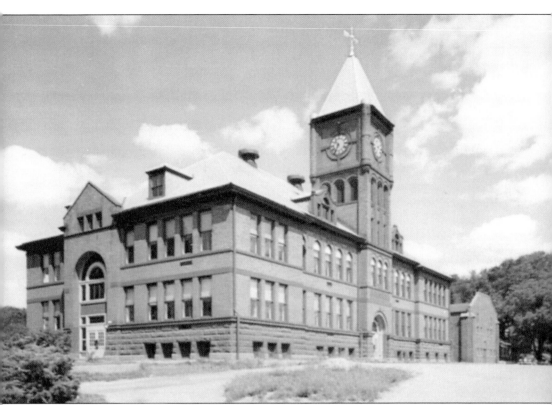

By the time of this postcard, students had graduated from this high school and gone on to take positions in the business community and beyond. Many worked in Chicago. When they came for a visit they always pointed out in which window they had their English or math classes. When a new school was built on the other side of town, this building was suddenly available for condominium purchase. Some people went to school in this building, lived in the community, and now wanted to retire and live their final years in the old high school. For some, it was as if they lived their whole lives within a few square blocks of Galena. Other people started to come back to Galena from Chicago. They wanted to return to the schoolhouse of their youth for their final lessons in life.

When co-author Kay Price came to this building, she was entranced by the romantic view of historic Galena. She settled in on the top floor and enjoyed every moment of her stay. She wondered why the clock no longer worked. No one knew. When the residents decided to have a Christmas party, she offered to write a little story for the evening's entertainment. It was so popular that she had it published. It was called "The General's Hat." The story is about Ulysses S. Grant and some mice that came to live with him in his house. The mice end up in the high school clock tower on Christmas Eve. When the vibration of the clock striking caused one of the mice to start to fall, the father mouse stuffed Grant's hat in the clock gears. It saved the baby mouse, but it also caused the clock to stop working. To this day, there is no better explanation. Price was persistent. To the delight of everyone, she got a local clock repairman to fix the bell tower clock. It worked until the day she moved out. (Photograph by Kay Price.)

Ten

BIRD'S-EYE VIEW
OF GALENA

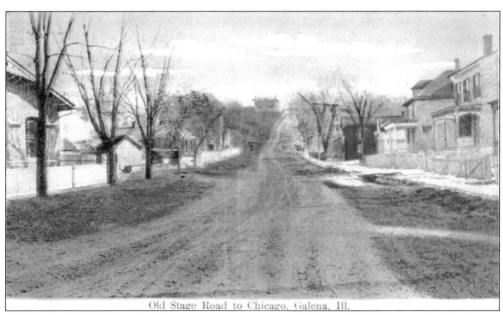

Old Stage Road to Chicago, Galena, Ill.

Other than using the Galena River for transportation, people had to ride their horse, use a horse and buggy, or travel by stagecoach. The Old Stage Coach Road to Chicago was the stagecoach route to the windy city. It was in operation by 1837 and closed down when the railroad arrived. It started out going from Chicago to Freeport and eventually made it to Galena. The scenic ride was much as it is today, with immense wide views seen from the top of high ridges and a pastoral landscape dotted with lush fields and few farmhouses. A favorite local pastime is to drive the scenic Old Stage Coach Road for a leisurely Sunday afternoon ride.

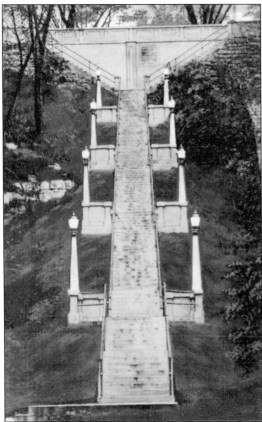

The original high school steps with their old fashioned light posts have recently been redone to look much like this early view. In December of 1873, the *Galena Daily Gazette* reported that "by actual measurement, Galena has two miles of steps—up and down—which a greater portion of its inhabitants meander from six to eight times per day."

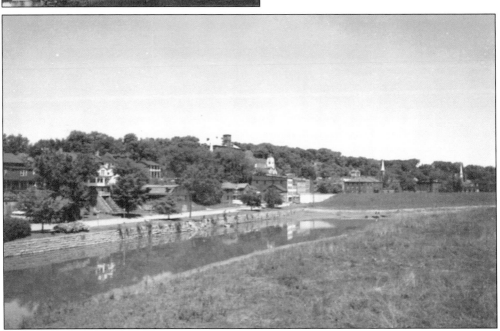

Picturesque pioneer Galena is located on the hills above the Galena River, as seen from the bridge on Highway 20. (Photograph by Henry Brueckner.)

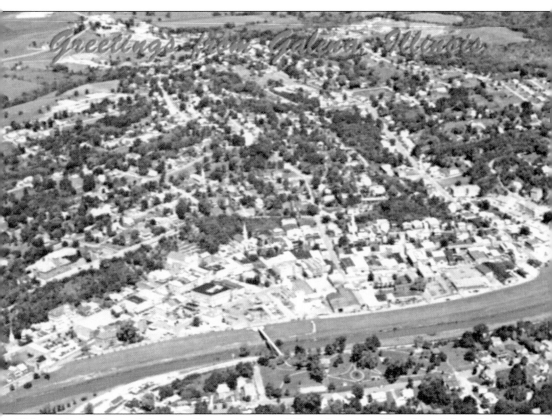

This aerial view shows Galena nestling against steep hills in the quiet valley of the Galena River. It is the oldest city in northern Illinois. This is a city rich in historical lore of French adventurers, gamblers, traders, stagecoach drivers, riverboat captains, and the early miners of the Civil War era. It is the home of Ulysses S. Grant, commander-in-chief of the Union Army and the 18th president of the United States.

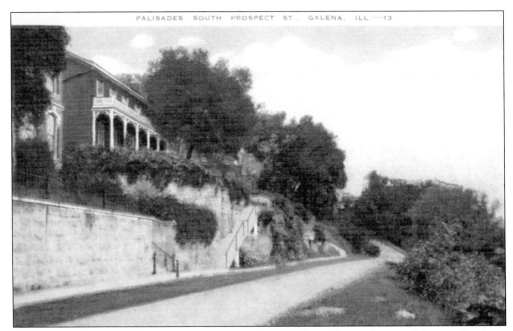

Prospect Street was here referred to as Palisades, which is a line of steep cliffs usually along a river.

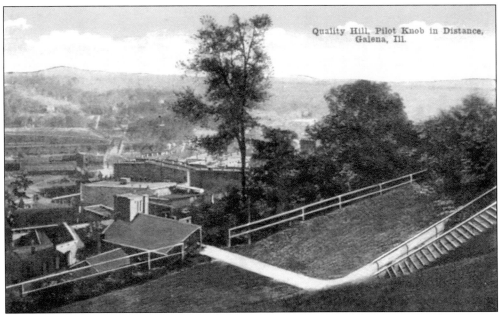

Quality Hill, Pilot Knob in Distance, Galena, Ill.

Quality Hill became Prospect Street. This early view shows distant Pilot Knob Hill.

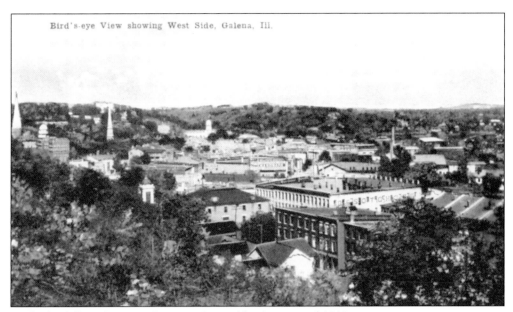

Bird's-eye View showing West Side, Galena, Ill.

As the bird flies, these are the views it would enjoy around 1910.

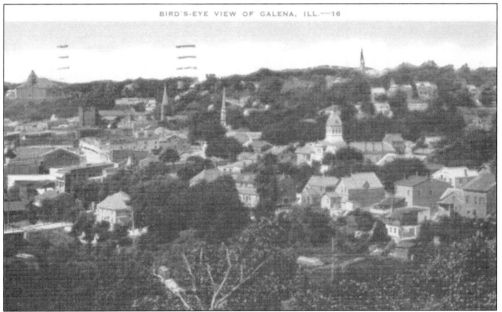

BIRD'S-EYE VIEW OF GALENA, ILL.—16

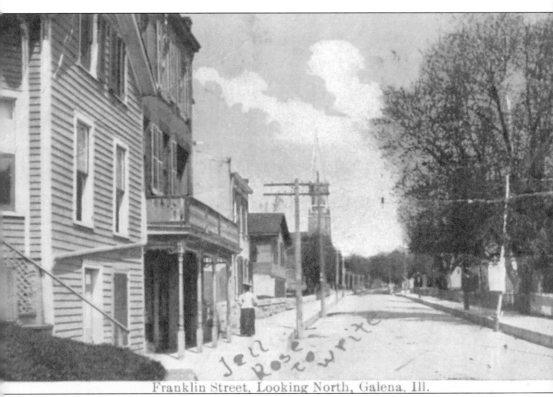

Franklin Street, Looking North, Galena, Ill.

In 1913, Franklin Street was a bustling part of town. This is where the grocery store, meat market, and saloon were found. People loved to mill around these areas to visit. It was convenient for the neighborhood to come here rather than make the long climb up and down the hill.

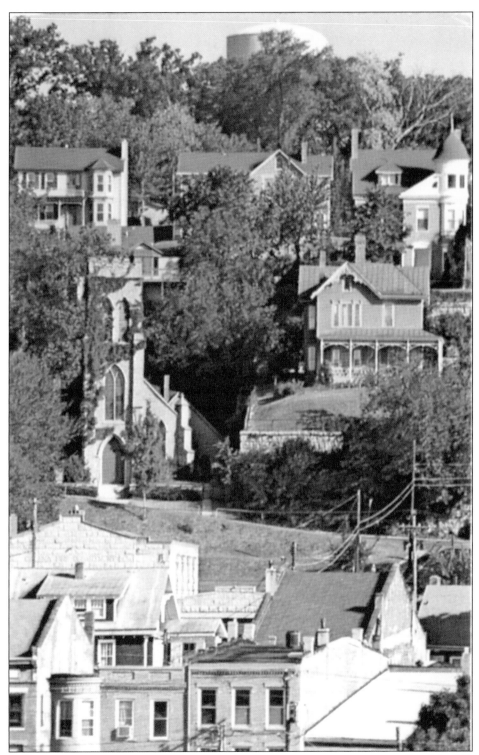

This enlarged view looking from Grant Park shows a staggering arrangement of brick buildings ascending the cliffs of Galena. (Photograph by Bob Coyle.)

Starting at the bottom and going up the hill, this image of Galena shows Main Street, Bench Street, and Prospect Street layered up the hillside. This old historic city is newly discovered by

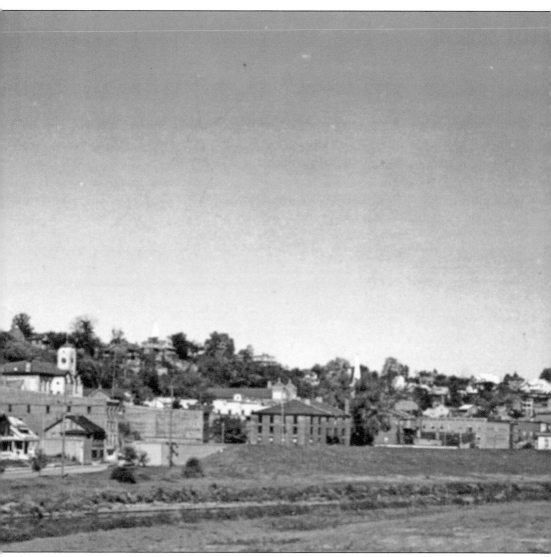

the million tourists who visit each year.

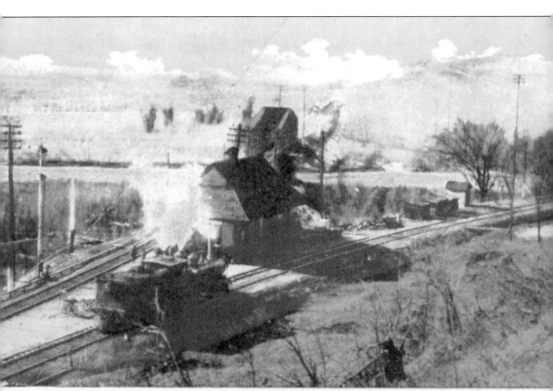

View of Galena Junction, Ill.

The Illinois Central Railroad came to Galena in 1854, during the time that Galena was the center of the lead mining region of the northwest. This Galena Junction was where the tracks joined on the edge of town. If another train like the Burlington on the Great Western came to town, this junction allowed cars to be dropped, or stored, or the train could be turned around.

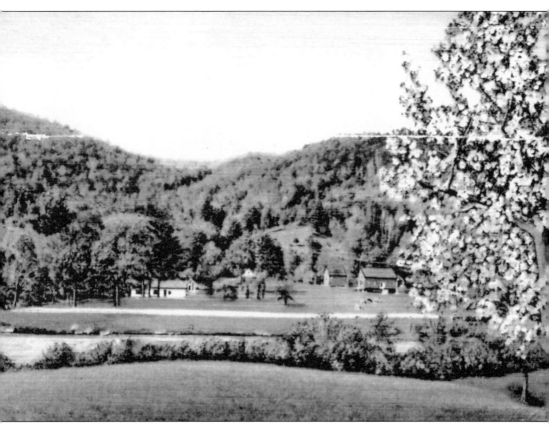

This is a very early pastoral view on the outskirts of Galena. The hills were alive with magic in this springtime setting.

Fish Trap, Galena, Ill.

Fish Trap is located near Ferry Landing, about a mile out of Galena. When the river would flood, water came back into this area. Fish were trapped when the water receded. This was a good place for fishermen to be when that happened.

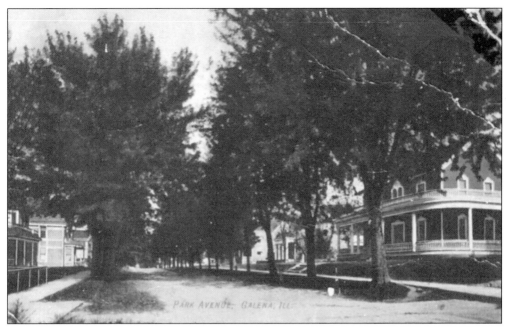

Park Avenue's tree-lined street is every person's dream of an ideal small-town life.

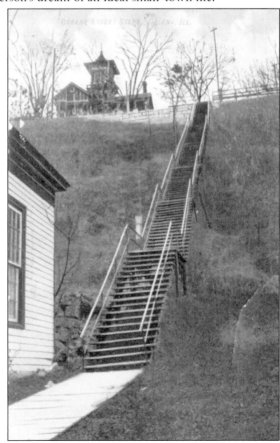

Another view of the old wooden Green Street steps, ascending up to Prospect Avenue, is seen here.

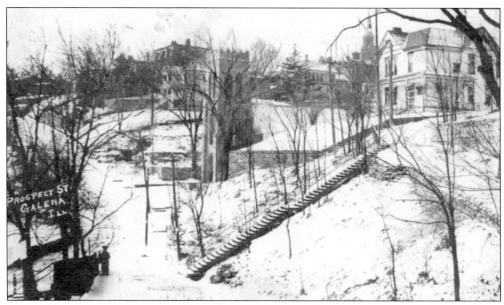

Wintertime on Prospect Avenue shows the Grace Episcopal church tucked into the hillside.

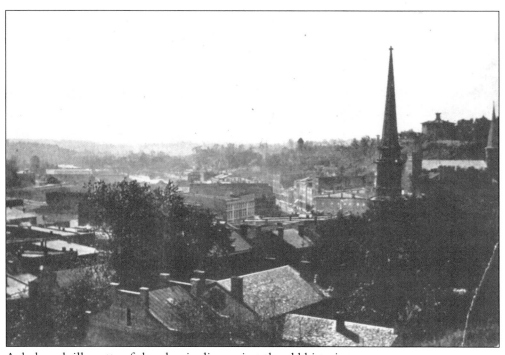

A darkened silhouette of church spire lies against the old historic town.

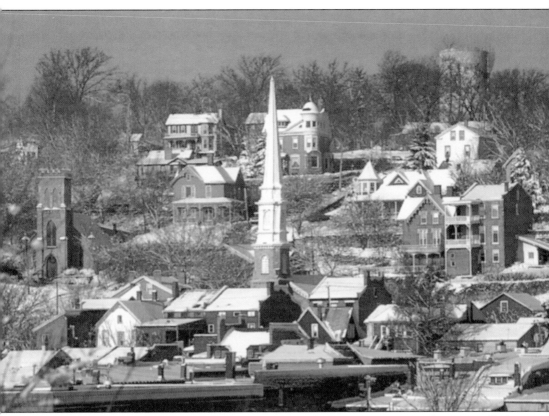

Like a Currier and Ives winter scene, Galena enchants all who see it. Once Galena was called "the town that time forgot." It was a prosperous lead mining center and thriving river port. It was one of the richest towns in Illinois in the 1840s. Then it became a ghost town that had to be rediscovered.

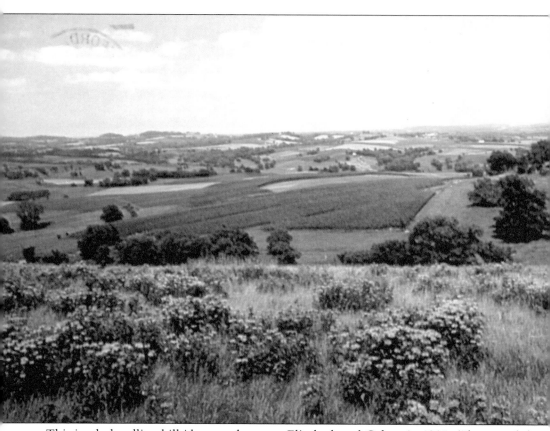

This is a lush rolling hillside scene between Elizabeth and Galena in 1985. (Photograph by Joe E. Clark.)

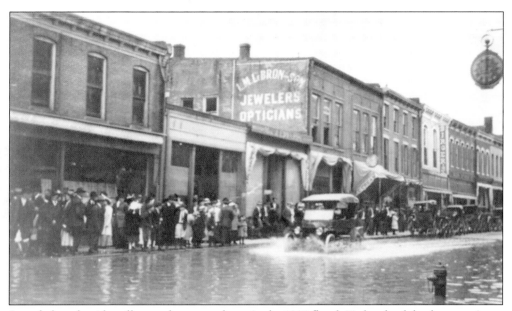

Stranded on the sidewalk, people are caught up in the 1915 flood. Today the dyke door continues to be closed in heavy spring rains to protect the downtown.

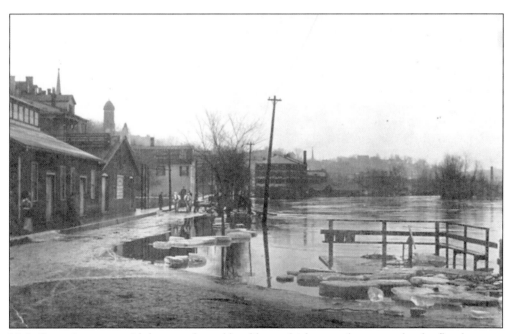

Main Street is strewn with large rocks and boulders, which were thrown up by the floodwaters.

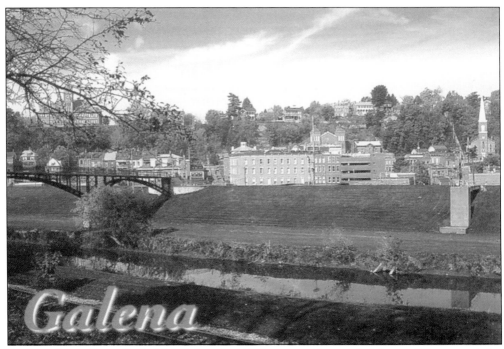

A view from Grant Park highlights the 1850s atmosphere of Galena. (Photograph by Nancy Lewis.)

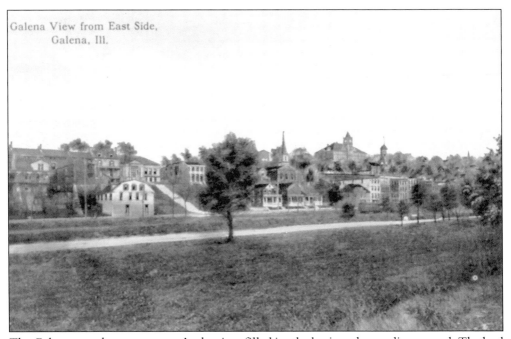

Galena View from East Side,
Galena, Ill.

The Galena steamboats are gone. As the river filled in, the business boom disappeared. The lead ore miners heard there was gold to discover in California, and there was a huge exodus to the western gold fields. The allure of the picture-perfect town remained.

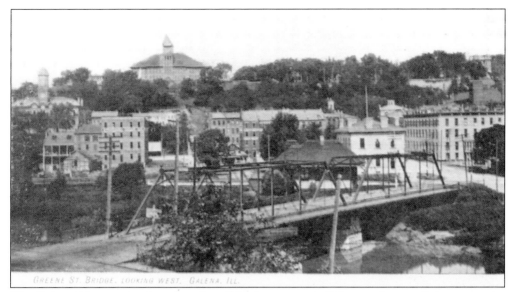

GREENE ST. BRIDGE, LOOKING WEST, GALENA, ILL.

The Galena River used to hug the edge of the downtown buildings and cross all the way to the other side of town. The river is now no more than a large stream. Isolated from the sprawl of a bigger city and blessed with the region's beauty, Galena has found its niche. Tourists from around the world come to see this historic haven of visual pleasures. (Photograph by Jim Doane.)

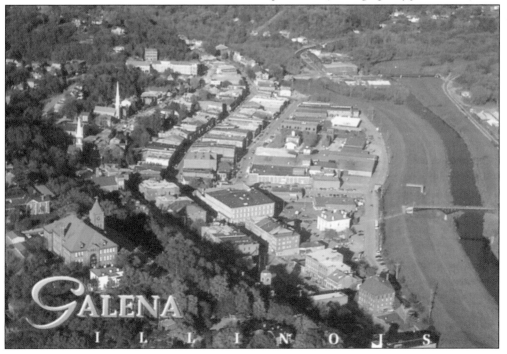

www.arcadiapublishing.com

Discover books about the town where you grew up, the cities where your friends and families live, the town where your parents met, or even that retirement spot you've been dreaming about. Our Web site provides history lovers with exclusive deals, advanced notification about new titles, e-mail alerts of author events, and much more.

MADE IN THE USA

Arcadia Publishing, the leading local history publisher in the United States, is committed to making history accessible and meaningful through publishing books that celebrate and preserve the heritage of America's people and places. Consistent with our mission to preserve history on a local level, this book was printed in South Carolina on American-made paper and manufactured entirely in the United States.

This book carries the accredited Forest Stewardship Council (FSC) label and is printed on 100 percent FSC-certified paper. Products carrying the FSC label are independently certified to assure consumers that they come from forests that are managed to meet the social, economic, and ecological needs of present and future generations.

FSC
Mixed Sources
Product group from well-managed
forests and other controlled sources

Cert no. SW-COC-001530
www.fsc.org
© 1996 Forest Stewardship Council

Find Your Place in History.